GHOSTS OF
CENTRAL JERSEY

GHOSTS OF CENTRAL JERSEY

HISTORIC HAUNTS OF THE SOMERSET HILLS

GORDON THOMAS WARD

FOREWORD BY LOYD AUERBACH
GARRETT HUSVETH AND AL RAUBER,
CONTRIBUTING EDITORS

Published by Haunted America
A Division of The History Press
Charleston, SC 29403
www.historypress.net

Copyright © 2008 by Gordon Thomas Ward
All rights reserved

Cover Image: The John Prall Jr. House at historic Prallsville Mills, Stockton, New Jersey,
2008. *Courtesy of Craig Schiavone.*

All images are courtesy of the author unless otherwise noted.

First published 2008
Second printing 2008
Third printing 2012
Fourth printing 2013

Manufactured in the United States

ISBN 978.1.59629.468.4

Ward, Gordon T.
Ghosts of central Jersey : historic haunts of the Somerset Hills / Gordon Thomas Ward ;
foreword by Loyd Auerbach ; contributing editors, Garrett Husveth and Al Rauber.
p. cm.
Includes bibliographical references (p.).
ISBN 978-1-59629-468-4
1. Haunted places--New Jersey--Bernardsville. 2. Haunted places--New Jersey--Somerset
Hills. 3. Ghosts--New Jersey--Bernardsville. 4. Ghosts--New Jersey--Somerset Hills. I.
Husveth, Garrett. II. Rauber, Al. III. Title.
BF1472.U6W36 2008
133.109749'44--dc22
2008024602

To Alison, a kindred and creative spirit.

CONTENTS

FOREWORD

G hosts? In New Jersey?
Who doesn't love a good ghost story?

The human tradition of telling tales of unusual, heroic, adventurous, romantic, humorous and horrific experiences is likely as old as language itself—and maybe older. Human beings have always conjured up stories to explain the inexplicable, to tantalize curiosity, to make us react emotionally or to get our adrenaline going. Tales of ghosts and hauntings, of things that go bump in the night (and day), are a special class all to themselves.

Ghost stories are fundamentally about us—the living *and* the dead. They are tales of human exploits and foibles, of motivations and unfinished business, of drama and comedy and, most of all, of emotion and history— sometimes recent, sometimes ancient. People love ghost stories because, while they often don't reflect the actual experiences of living people (the ones who see/experience the ghosts), they sure *seem* to be real.

While generally scary (or at least suspenseful), ghost stories have one underlying point that says something very important: we continue on in some kind of existence *after* the death of our bodies. While most ghost stories don't address the issue of the afterlife as a place/dimension that we go to (the ghosts in the stories are still here with us), in that respect they do reflect the real reported experiences, encounters and paranormal/psychic investigations of apparitions, hauntings and poltergeists.

People are fascinated with the unknown, even if it brings up their fears— or perhaps precisely because it does this. It is also clear that people seem to be drawn to that which brings up strong emotions, even if those emotions are negative.

So, what's the difference between a fictional ghost story and one that's true (based on actual human experience)?

Content-wise, while the fictional ghost story may follow similar parameters as most ghost experiences, there is usually at least some exaggeration, dramatization and such for the sake of the telling of the tale. But more often, the "some" is actually "great," and the behaviors and motivations of the ghost are completely made up to make the story more dramatic, scarier, funnier and so on—more emotionally evocative. Even the history of the haunted location in the story is exaggerated, misrepresented or completely fictional.

Which brings me to this book, and the tales in it.

For an investigator of the paranormal, especially parapsychologists conducting field investigations, verifiable information about the location and/or the person(s) the ghost(s) represent(s) is extremely important to both support the experience as essentially *real* and to help solve the case—to help us determine what (or who) is the source of the experiences.

Most of the cases that parapsychologists investigate tend to involve families experiencing something that may have only a small, verifiable component—usually information gleaned from communication with the ostensible apparition or perceptions about that bit of place memory/ residual haunting that is repeating itself. Since most people don't live in homes of great history, we usually try to track down whatever is available from previous owners, public records, local newspapers and neighbors.

In the case of public places such as museums, historical sites, restaurants, bars and so on, there can be both a well-established history of the location and long-term ghost sightings. For the history, one must often check the reality of what's known, since the history that is sometimes passed around is more of an oral history that doesn't hold up completely against the actual historical record. One often finds the ghost story began or is connected to a false recollection or recording of history. The motivations or identity of the ghost or content of the imprint connected to the wrong person(s) or events either happened differently than told or didn't happen at all.

As far as the ghost story is concerned, we hope for current and recent witnesses to the situation—living people who can be interviewed about their experiences. In true haunting and apparition cases, the experiences are relatively consistent throughout the years.

For the history, we do historical research, or turn to the local historians who have already done that research.

I currently live in California (have for over twenty years), but I was born and raised outside of New York City. It's quite interesting to see the differences in ghost stories from coast to coast. From Americentric and Eurocentric points of view, the East Coast generally has a longer history. Though the Spanish were in California for quite a long time, the population

density for that older history was much, much lower than that of the original thirteen colonies. More people, more history, more ghosts—and more haunted locations with more history.

On the West Coast, "old" might mean a place built in the early 1900s. In New Jersey, the same word may refer to places with history dating back to the 1700s.

Some locations resist research attempts to connect the ghost with the history. In such instances, we have only eyewitness testimony on which to rely. Their experiences are quite real and are indications of psychic experiences, but are not verifiable from a historical perspective.

We always hope for cases where the history can be correlated to the reported experiences, and we hope that the history can be confirmed. The best cases are those where it was tough to find these correspondences between experience and history. If it's tough for someone to research and locate, it's unlikely the witness simply made up the experience.

In this book, you'll read about places with ghosts and their perceived history. But more, you'll see where the perceived history, the history told over and over again (and especially the history that "explains" the ghosts), is verified by historical research...or not.

Ghost hunting is, or rather should be, about *who* the ghost is and *why* he is there, or *what* events or people imprinted themselves on the environment. What you often see on television shortchanges the process of investigation. It's often bad coverage, or rather bad editing, that focuses on the ghost hunters and their gizmos, which only register environmental changes or odd things photographed, instead of the phenomena that they're actually investigating.

For those of us truly interested in haunting experiences, apparitional experiences and apparitional phenomena, we need to dig into the reports and the stories, and find what's at their roots.

Is it really a ghost? A residual haunting?

Or has the local legend become the local belief?

Enjoy the stories of these locations in haunted New Jersey—the history will come alive (or maybe become undead) for you through the ghosts.

Loyd Auerbach, M.S.
Instructor, HCH Institute Parapsychological Studies, www.mindreader.com
Director, the Office of Paranormal Investigations
Advisory Board, Rhine Research Center

PREFACE

I've always thought that the best historians are the ones who can use their mind's eye to "see" those people and civilizations that existed before us. If one can put oneself in the picture, if one can blur the lines between past and present, history takes on a relevant, personal quality that is so much more than words on a textbook page. If you are like me, there have been times when you may have visited places such as Gettysburg, Fort Ticonderoga, Princeton Battlefield, Salem, Williamsburg or other similar locations and felt the presence of those that have lived in these areas and passed from this world. You may have felt the energy in these places and begun to understand the past in a way that can not be accomplished from a remote location. You simply have to be there to perceive and fully experience the energy.

Then, at other times, you may have felt that sense of companionship when nobody was around you. There is a communion sensed with someone whom you can not see, but know are there—perhaps a loved one, friend or family member. These are the experiences that poets have celebrated and honored for thousands of years. They are part of the human condition, our link with the eternal, and they are the inspiration and the source from which the content of this book flows.

It is not my goal to convince you to agree with everything I express on these pages. Rather, it is my hope that you will at least consider that the things for which we have no clear explanations, and for which we can only collect evidence today, may one day be proven to exist. One of the best tools and vehicles to get us to that point is an open mind.

Contact the author at gtwservices@optonline.net.
The author's website can be found at www.gtwservices.com.

ACKNOWLEDGEMENTS

In the process of writing a book, I always find myself indebted to many individuals who have contributed their time, information, assistance and support. This book is no different.

First and foremost, I'm thankful for my children, Melina and Cory, who have always shown an interest in the projects I have chosen to pursue.

A very special thanks goes out to Loyd Auerbach (Instructor, HCH Institute Parapsychological Studies; Director, the Office of Paranormal Investigations; Paranormal Research Organization; Adjunct Professor, JFK University; Advisory Board, Rhine Research Center; Scientific Advisory Board, Forever Family Foundation; www.mindreader.com; esper@california.com) for his thoughts and words, to Garrett Husveth and Al Rauber for their advice, professionalism and participation and to Craig Schiavone for his time, enthusiasm and photographs.

Others, be they friends, associates or experts in various fields of knowledge, deserve special mention as well. In alphabetical order they are Kate Bailey, Fred Bartenstein Jr., Noel Baxter, Joseph Bonk, Tom Carlin, Bea Dreesen, Meredith Freeman, George Fricke, Ashley Haughton, Paul Healy, Jean Hill, Nelson Jecas (for access to the former Bernardsville Library site), June Kennedy, Marion Kennedy, Olga Khalin, W. James Kurzenberger, Tina Legge, Marge Margentino, Marcella Miccolis, Marie Newell, Ann Parsekian, Carla Schenk, Edie Sharp, Dan Sturges, Daryl Anne Villard and Anna Wyman.

Writing is not as solitary an endeavor as it may sometimes seem, and my appreciation for all of your aid and input is more than can be sufficiently expressed.

Chapter 1

PORTAL

A house is never still in darkness to those who listen intently; there is a whispering in distant chambers, an unearthly hand presses the snib of the window, the latch rises. Ghosts were created when the first man awoke in the night.
– J.M. Barrie, Little Minister

I was puzzled more by my father's reaction than by the phenomenon itself. When I was seven years old, my father seemed to know everything. He was, after all, a college professor, so I believed that there wasn't much in this world that he could not explain. Having said that, you might better understand why I stood with my mouth agape when my father, for the first time I can remember, said, "I don't know." His unexpected words seemed to linger in our upper hallway like one's warm breath when it meets the frigid winter air. It was lightning striking, and I knew at that moment that I was determined to find the explanation for the phenomenon we were experiencing.

The phenomenon in question was the muffled conversation that emanated from my home's first floor and drifted up our stairway in the dark of night. It sounded exactly like several people having a discussion, but the words were impossible to discern. It occurred several nights per week, steady, never changing in intensity or location, and it always ceased abruptly whenever anyone set foot on the top tread to descend the steps—almost as if it knew when one of us was approaching. After it stopped, the conversation would often resume several hours later. Everyone in my family heard it, even some guests, and we all came to accept this paranormal phenomenon, and the others that occurred in our house, as part of the fabric of our dwelling place—real things that existed within the walls of our home. They seemed to belong as much as we did.

The house of my childhood in Bernardsville, New Jersey, developed a reputation for being haunted. There was an apparition of a man in a light

Darkened sky over Stockton, New Jersey, 2008. *Courtesy of Craig Schiavone.*

shirt and dark pants that was seen twice in the dining room, and there was another apparition of a woman that appeared in a bedroom doorway. When you live in an older home, you get used to its "normal" sounds, so my family and I became rather adept at picking out the "unusual" sounds. We experienced the sounds of loud crashes and bangs that occurred without anything being found out of place to explain them. In the evenings, there was often the sound of someone ascending the stairs. Footsteps were heard on the second floor when no one was up there, and other footsteps were heard on the porch late at night, followed by the rattling of the front door handle, which happened to be inside a locked screen door. Upstairs doors would open and close, and no breeze or other explanation could account for their movement. A potted Christmas cactus was seen by three people to rise off of a planter, move three feet away from the planter, hover in the air for several seconds and then crash to the ground. A number of clocks, one of them a watch that lay discarded and hidden at the bottom of a drawer, reset and/or stopped themselves at 4:28 p.m. And there was also the constant feeling of something watching you on and from the second floor, whether you happened to be inside or outdoors. When people would descend the stairs from the second floor, many of them, including guests and other family members, described feeling something like a pressure behind them. It was almost as if you felt you weren't welcome, and you couldn't get down the stairs fast enough.

As I mentioned, however, my family got used to these events. It wasn't as if these events happened every day. Other than the muffled conversation and the feeling of being watched on the second floor, things would catch our attention at a rate of perhaps once every several months. Paranormal events also occurred at neighbors' homes and in other parts of our extended neighborhood as well. I was literally surrounded by reports of the paranormal since I was a child, and so it was that I developed a keen interest in the reports, study and documentation of ghosts.

I don't believe that anyone can argue against the existence of ghosts. They exist. Their reports have, after all, been with us since the dawn of mankind, entwined throughout history and stretching across cultures and socioeconomic strata. They've been seen by the young and old, the simply schooled and the erudite, dreamers and men of science. Ghosts even exist in the Bible. No, one cannot argue against their existence, but one *can* argue what the phenomena are and how they can be explained. Explanations range from flights of fancy to the spirits of humans endeavoring to make contact from beyond the grave. In between these are the explanations that equate ghosts with various types of energies or psychic impressions that are imprinted on environments.

If you find this too strange to fathom, consider this: if one were to take a digital audio recorder back to seventeenth-century Salem, Massachusetts, and record someone's voice, one might very well end up being hanged as a witch. The collective knowledge at that time wouldn't be able to conceptualize or explain it, and people often fear what they can't explain. Ask any scientist, and you'll be told that as much as we know of the workings of our universe, we have barely scratched the surface. There is so much left to discover, and I believe ghostly phenomena are part of that great unknown. The worst things we can do are ignore the things that we can not explain, sweep them under the rug or dismiss them as nonsense. There are just too many credible reports out there to do that. The best we can do is to try to substantiate the reports with a healthy skepticism, physical evidence and an open mind.

Before we move on, I think it prudent at this point of the book to do some explaining about different types of ghostly phenomena and electronic voice phenomena (EVP). A "haunting" is defined as the repeated manifestation of strange and inexplicable sensory phenomena—smells, sounds, sights, tactile sensations—said to be caused by "ghosts" attached to a certain locale. Within this definition, we can divide the ghostly phenomena into three categories: residual (also called "place memories"); poltergeist; and apparitions.

Let us first deal with the residual type. Think of residual phenomena as leftover, recorded energy. In this case, ghosts have no more to do with the grave than a movie or audio recording has to do with the physical presence of the actors or singers. The images, scents and sounds are recorded energy and nothing more. One of the theories pertaining to ghosts is that they are the result of energy that sometimes gets imprinted upon a building or environment. When the right conditions occur, or people with enough sensitivity are present, these recorded events replay themselves and can be perceived.

We all have different strengths. For example, barring accident or illness, we all develop the ability to run, yet only a few of us are of Olympic caliber. Some of us are better at mathematics, while others are stronger with languages. There are people who can draw and paint, and others who have little talent in these areas but have amazing abilities in sports and athletics. The bottom line is that we are all unique, and while all of us have some degree of psychic ability, some individuals are more sensitive than others. This explains why some people sense phenomena that others can not. I'll give you an example. I'm slightly colorblind. There are some shades of green and red that I just can't see as well as others. The red-and-green traffic lights are no problem for me, but I'm often tripped up by those small LED (Light Emitting Diode) lights that are found on some microphones and other electronic equipment. Typically, the red LED changes to green when the unit is on mute. Try as I might, I just can't see the color change. Someone right beside me can see it, but I can't. It's not that there's something wrong with the lights. The problem lies in the manner by which the receptors in my eyes process the light.

Think of the information recorded on a CD. You can keep the CD in your house forever, but if you don't have a CD player and speakers, the recording can't be experienced. It's much the same with paranormal phenomena, especially the residual type. Given the correct conditions and the people with enough sensitivity, the events will be experienced. Much like a CD, residual phenomena, whether they are visual, olfactory or auditory, don't change. They repeat themselves and do the same thing each time they are sensed, which is why this group of phenomena is sometimes classified as "time/place" or as "place memories." These place memories are recorded in and rooted to a very specific time and/or location. You wouldn't expect a song on a CD to suddenly end a different way, and you wouldn't expect an actor in a movie to change his lines or speak to you. Similarly, residual phenomena do not change and do not interact with people because they are not conscious and do not possess intelligence. They are simply recorded energy, and there is no more to fear in this case than there would be in viewing a movie or listening to an audio recording.

The second type of phenomena is often referred to as a poltergeist, meaning "noisy spirit." A poltergeist is most times not a spirit at all, but rather a manifestation of a person's own energy within the physical environment, an event called *psychokinesis*, defined as a technique of mind over matter through invisible means. In times of physiological change or mental stress, it's theorized that a person's own energy can be responsible for the movement of objects or other phenomena that appear to be caused by an external source. Most times, the reoccurrence of poltergeist phenomena is rather short-lived, lasting somewhere between a few months to a year. Often times, it is centered on an adolescent, and most times the adolescent is female. Poltergeist activity is *not* like most of the activity seen in the movie *Poltergeist*. Hollywood did a great job creating a frightening movie, but it is not what one finds in actual cases. Movement of cups, chairs, doors and the sound of bangings and rappings fall into the poltergeist phenomena category, although they can sometimes be associated with other types of ghostly phenomena. While unnerving, there is very rarely any cause for alarm.

The third type of phenomena is considered to be the holy grail of paranormal investigation—the apparition. Parapsychologists use the term "apparition" to indicate conscious, intelligent, interactive "ghosts." While the term literally relates to visual sightings, the idea is sense-independent in the last one hundred years of parapsychology and psychical research. There are auditory apparitions (heard only) and olfactory apparitions (smelled only), but, generally speaking, apparitions are experienced through a variety of perceptions. In the case of apparitions, there is a clear indication that the entity has an intelligence and is conscious of events in the environment. These phenomena respond to human activity. They may motion to you, acknowledge one's presence, change their behavior and communicate. This is the classic image portrayed in *Hamlet*, where the prince has a dialogue with his deceased father. There is give and take between entity and human. Intelligent phenomena may involve visual sightings of apparitions (an extremely rare occurrence), touches, voices and sounds, even moods swings, tastes and scents. Apparitions, as they are strictly defined, are extremely rare. The key is that they respond and interact with the physical plane and are conscious of events going on around them.

Consider this metaphor. When we disrobe at the end of the day, we step out of our used clothes, but we still exist. Similarly, our spiritual essence still exists after we shed our physical bodies. How would you feel if people were to think that you no longer existed simply because your previous day's clothes were empty and unanimated? This is one reason why I do not agree with trying to provoke entities that are believed to be at a site. If you

wouldn't do it to a person on the physical plane, then you shouldn't do it to someone on a spiritual plane. Any attempts to do so are rooted in selfishness and arrogance. We tend to mourn people as ceasing to exist at the death of the physical body, but perhaps we only step out of it to exist on another level. If that is the case, and our consciousness survives, then there may be times when the spiritual and the physical planes intersect and interact, and we as humans may be able to find evidence of that.

The collection of forensic evidence is becoming a more common practice among paranormal investigators. Photographs are often offered up as proof of a ghost's presence; however, most "ghost photos" can be explained away as camera straps, insects, water vapor or dust caught in the camera's flash and lens. The classic photo of an "orb" is the most common and can usually be explained away as dust. These objects of various sizes, looking very similar to a dandelion gone to seed, appear as though they are hovering in space several feet from the photographer when, in reality, they are tiny droplets of water vapor or dust particles very close to the camera lens and reflecting the light from the camera's flash. If you want to try to make these orb photos for yourself, take a flash photo of a room in your home. After you've done this, beat some pillows together, blow some talcum powder into the air or do something else to kick up a bit of dust. When this is accomplished, take another flash photo. If you stand where the dust is located, you'll capture the image I'm describing. Many times, the photo will capture multiple orbs of different sizes, but you'll see that they all share a similar quality. The only orb photos that bear any consideration for extended study are those very few that seem to emit their own light, and even many of these wind up being explainable.

Another type of forensic evidence is electronic voice phenomena, usually referred to as EVP. This is the recording of anomalous voices, typically consisting of short utterances of just a few words. Recordings of these voices have involved almost every known technology that is capable of supporting human voice. Some people use tape recorders to capture these voices, but most investigators tend to use digital voice recorders, which allow the recordings to be downloaded onto a computer for analysis.

EVPs are divided up into three classes: A, B and C. Class A consists of voices that can be heard as easily as any human voice on a speaker. It is clear and can range from a whisper to a shout. Class B voices are more difficult to discern, often requiring special attention in order to hear it. Class C is most times a whisper and necessitates the use of headphones and audio enhancement. One intriguing point about EVP is the fact that they respond directly to questions. Posing a specific question, the investigator will often get an intelligent reply. EVP voices can also be male and female, from full voices to whispers.

EVP voices are not heard at the time of recording but appear audible upon playback. Voices and other sounds that are of a paranormal nature and are heard naturally by the human ear without the use of recorders or audio enhancement are referred to as "direct voice." The developing consensus supports the theory that EVPs are not produced using sound waves at all. All sound on this planet needs a medium through which to travel. Whenever you or I speak, we employ the vibration of our vocal cords, and the resulting sounds travel through air molecules. Spirits, entities and ghosts (call them what you will) do not have diaphragms or vocal cords, and we think they modulate their voices using the electromagnetic fields of the earth or those belonging to the recording devices themselves, which is why EVPs are only heard when the audio recordings are being played back. Supporting this theory are the results of some EVP researchers that record voices on hard drives without using any microphones. It may be that the microphones used in EVP recordings are really only recording the researchers' questions. Whether one believes that the EVP voices belong to disincarnate entities or not is up to each individual to decide for themselves, but no matter what one's beliefs are, the phenomenon is interesting as a form of tangible documentation.

Thomas Edison is quoted as saying that it might be possible

> to construct an apparatus which will be so delicate that if there are personalities in another existence or sphere who wish to get in touch with us in this existence or sphere, this apparatus will at least give them a better opportunity to express themselves than the tilting tables and raps and Ouija boards and mediums and the other crude methods now purported to be the only means of communication.

Bear in mind that EVPs are not proof of the existence of ghosts, but, due to the signature they possess when analyzed, they are rock-solid evidence of anomalous voices. EVP voices contain all the forensic signatures of the human voice. To that end, one will find an appendix at the end of this book that includes website links to some of the EVPs my associates and I have collected at the sites in this book. In order to accommodate the broadest band of readers, most of the EVPs contained in this book's appendix will be restricted to Classes A and B and will not require the use of headphones to hear them.

This brings me to collection procedures, which is really a subcategory of investigation procedures. As in any investigation, the collection of evidence must be accomplished in a manner that will yield high-quality and reliable results. This means that every effort must be made to ensure that the results

are not contaminated or misinterpreted. When you are dealing with historic locations, this can become a significant issue. Old buildings creak and make noises that locations of newer and more modern construction may not. Wood expands and contracts, stone echoes and heating and air-conditioning vents are often retrofitted and relegated to any available nook and cranny. Many historic locations have human noise levels that are difficult to eliminate, and such locations that are out-of-doors have additional environmental noises that can be challenging to overcome.

When investigating a site, it is imperative that the area be researched thoroughly. Knowing the background of a site can help immensely in the interpretation of evidence. When was the location built? Who built it? What happened at the site? What is the history of paranormal events? Get names, get dates, corroborate your findings like any good historian and collect as many eyewitness accounts as possible. Stabilize the environment. Look for tree branches that may rub on windows and roofs. Note the type of sounds produced by the heating system. Make sure items at the site are not precariously balanced on shelves and counters, and familiarize yourself with the normal sounds that the site and the building make. When it comes to recording EVP, be mindful of the noises that you and your group create. If you find that you make a noise, note it by mentioning it loudly and clearly on your recorder. This will eliminate any confusion when reviewing the recordings at a later date.

Most importantly, make sure that you know where all the members of your team are. This is made easier by restricting the investigation to a small number of investigators. You must also make every possible effort to know, without a doubt, that no one outside of your group has a chance to contaminate the area with false evidence. Always look for explanations for evidence that are outside of the paranormal. The better initial job that one does of examining results with a skeptical eye, the more reliable your remaining evidence will be.

All this being said, let me take you on a tour. Having been both a teacher and a student of history, I am impressed by the number of times that historic sites have their fair share of ghost stories and reports of paranormal activity. Blending my interests together, the act of writing about historic locations and their ghostly phenomena was a natural thing for me to do. Assisted by input from Garrett Husveth and Al Rauber, who are my associates, contributing editors and co-members of Haunted New Jersey (a paranormal investigation group), I will take you to several historic locations in Hunterdon and Somerset Counties in New Jersey, where the past does not always remain in the past, the dead seem to exist alongside the living and disembodied voices of the "dead" reach out to make themselves heard.

Chapter 2

THE FORMER VEALTOWN TAVERN AND BERNARDSVILLE LIBRARY

For who can wonder that man should feel a vague belief in tales of disembodied spirits wandering through those places which they once dearly affected, when he himself, scarcely less separated from his old world than they, is for ever lingering upon past emotions and bygone times, and hovering, the ghost of his former self, about the places and people that warmed his heart of old?
– *Charles Dickens*, Master Humphrey's Clock

The threat of heavy snow hung in the frigid air surrounding the Vealtown Tavern. Lamplight burned behind the shuttered windows, betraying a kindled warmth that glowed in sharp contrast to the brittle winter night, while wood smoke rose and trailed above the chimneys of the establishment, vanishing like wraiths into the night sky. The date was January 29, 1777, and the sleepy hamlet of Vealtown—which would one day have its name changed to Bernardsville in honor of Francis Bernard, the royal governor of New Jersey from 1758 to 1760—was becoming familiar with the sights and sounds of weary troops as General George Washington's ragged and dwindling army passed through the town, wintering only a few miles away from the tavern's door. Little could anyone guess that the events of that evening, alleged to take place both in and around the little tavern, would go on to become one of the most famous ghost stories from the American Revolution.

Encouraged by their recent victories at Trenton and Princeton, the Continental army spent the early months of 1777 huddled in Morristown. The Watchung Mountains to the east not only afforded protection from the British troops, but they also allowed the Continental army to monitor their enemy's troop movements across the plains of New Jersey. The area around Morristown afforded General Washington almost everything his troops might need. Food and grain, gunpowder, tools and shelter were

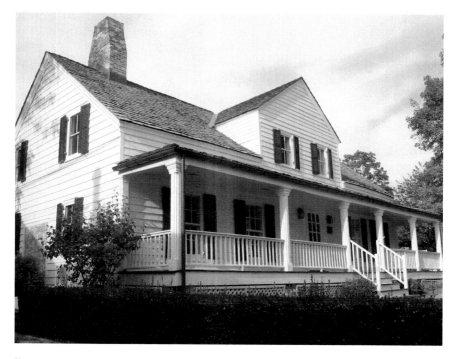

Former Vealtown Tavern and Bernardsville Library.

close at hand. The five thousand soldiers found shelter anywhere they could. Barns, private homes, stables and tents were employed to keep the men as comfortable as possible, but that's not to say that the army was without hardship. There were severe shortages of food and clothing, and spending winter in the New Jersey hills was difficult. To make matters worse, smallpox spread throughout the army and the surrounding communities. Two churches in Morristown served as hospitals, and sickness and death seemed to be encroaching upon them from every direction. In a move that was just as risky and dangerous at the time as the smallpox disease itself, Washington ordered the area's civilians and his soldiers inoculated. Through it all, desertion and the expiration of enlistments gnawed away at the ranks. Somehow, Washington and his officers remained confident and determined to strengthen the troops, and when spring arrived in the area, the Continental army rebounded in strength and numbers.

As one might imagine, there are many accounts and stories that emerged from this ordeal. Some spoke of the soldiers' courage in the face of environmental adversity. Others described less honorable instances where the local militia annoyed and troubled the local farmers—actions that did nothing to help their cause. Still, others dealt with the life of the soldiers and the drama that played itself out in the hamlets surrounding Morristown.

One such hamlet was Vealtown, and it drew the attention of the Continental army due to its location on the road leading north from Pluckemin to Morristown. The town could also boast of the Vealtown Tavern, a location that was frequented by soldiers and townspeople alike. Built in 1710, the white clapboard structure is listed on the National Register of Historic Places and sits in its original location, just east of the Bernardsville town square on Route 202. During the Revolutionary War, the tavern was owned by Captain John Parker, leader of the local militia. The story that is about to be told has many different variations, so I will relate to you a version that incorporates as many of the points as can be accomplished without getting too bogged down in the differences among the accounts.

It is said that Captain Parker had a very pretty daughter named Phyllis, perhaps sixteen years old at the time of this account, who helped her father in the tavern operations. Phyllis was courted by a man by the name of Dr. Byram, who was a tenant at the tavern. Dr. Byram was a young physician who had established a practice in the area and was the gentleman with whom Phyllis had fallen desperately in love. Some accounts have them becoming married, while others have them courting, being lovers or engaged to be wed. In any event, the intent of the account seeks to establish that Phyllis and Dr. Byram saw each other regularly. This must be perfectly understood if one is to grasp the gravity of this story.

On the night of January 28, 1777, and not long after their victory at Princeton on January 3, some of George Washington's officers stopped at the Vealtown Tavern in search of relaxation and lodging. Washington's army had just halted at Pluckemin, and a number of the troops stopped at Vealtown, as it was about the midpoint in the journey north from Pluckemin and toward Morristown, the location of their permanent winter quarters. General Anthony Wayne, moving north from Princeton with General Washington's troops, was just one of the distinguished officers that arrived at the tavern that brisk evening, and he carried with him a courier pouch that contained official and important papers noting future troop movements of the Continental army.

Phyllis and Dr. Byram were also in attendance that evening, enjoying each other's company in the sitting room. Upon noticing the important rank of the newly arrived officers, Byram excused himself, feigning illness, and retired up to his room for the rest of the evening. As the night wore on, General Wayne and the other officers enjoyed the merry atmosphere of Captain Parker's tavern and eventually made their way to their respective rooms for the night.

When daylight broke, Dr. Byram was gone, and his horse was missing from the stable. Being a physician, this was not unusual, for he was often called

away without warning to attend to the medical needs of the community. General Anthony Wayne arose later in the morning and urgently summoned Captain Parker to announce that he had been robbed at some point during the night. The papers from General Washington, which Wayne had been entrusted to deliver to Morristown, were missing, and it was suggested by Wayne that there must be a spy in the neighborhood. Captain Parker and General Wayne were able to account for everyone in attendance that evening with the exception of Dr. Byram. When General Wayne asked for a description of the doctor, Captain Parker produced a miniature picture of Byram that had been given to Phyllis. It is said that General Wayne immediately recognized Dr. Byram as the notorious Tory spy Aaron Wilde, despite the fact that the picture showed Byram with a beard and long hair.

Wilde was the Tory spy already under suspicion for indirectly tipping off the British about the movements of one of Washington's other officers, General Charles Lee, information that resulted in Lee's capture. The British had actually been given news of Lee's plans to visit the neighboring town of Basking Ridge by a Mr. Mickelworth of Mendham, who was upset about being cheated on the price of a horse. It's said that Aaron Wilde was overheard talking about British troops in the area, and Mickelworth sought them out. The night before Lee's arrest, the British had hidden in the fields behind the Widow White's Tavern, an establishment that no longer exists but used to be located on what is today the southwestern corner of South Finley Avenue and Colonial Drive in Basking Ridge. Waiting out the night, the British captured Lee at the Widow White's Tavern early on the morning of December 15, 1776, while he was indulging in, shall we say, professional female companionship. Apparently, the arrest of General Lee was not without conflict, as revealed by the following description in John H. Barber and Henry Howe's *Historical Collections of the State of New Jersey/Somerset County History*:

> *A respectable elderly lady, now a resident of Baskingridge [July 1842], and who at the time Lee was taken lived in this vicinity, states that two of the guard retreated about 40 rods in a northwesterly direction. They were pursued, overtaken, and refusing to surrender, were killed. The cavalry, from fear of alarming the American troops in the vicinity, by the report of their fire-arms, used their sabers only, and hacked them so terribly that it was found very difficult to remove their bodies to the graveyard, and they were put in boxes and interred in the field where they fell.*

As a result of Wayne's recognition of Byram as a spy, an immediate manhunt ensued. This resulted in Byram/Wilde being located at the Widow

White's Tavern and kept under surveillance for several hours. Dr. Byram eventually left the tavern in Basking Ridge and was captured at a place known as Blazure's Corner. This location is now marked by the intersection of Childs Road, Mullens Lane and Old Colony Road in Bernardsville and sits about six-tenths of a mile east of the Vealtown Tavern site. At the time that Dr. Byram/Aaron Wilde was arrested, he was found to have the incriminating papers (Wayne's missing documents) on his person. Aaron Wilde was taken to a house that stands to this day on the corner of Old Colony Road and Childs Road, convicted of espionage based upon the papers found in his possession, sentenced to hang and granted just enough time to write Captain Parker to beg that his body be given a decent burial. Fulfilling the orders of General Wayne, a rope was then fitted around Wilde's neck, and he was hanged on the spot. The total elapsed time from the moment of arrest to the time the last shudders of life trembled through Wilde's body at the end of the rope was no more than thirty minutes.

Captain Parker, who initially had his doubts about Byram's role as a spy, was horrified to find that the man her daughter loved had been hanged, and he decided to keep the news from Phyllis. Captain Parker was granted permission to see that the body was cut down and provided with a proper burial. He arranged for the doctor's body to be nailed inside a wooden crate and brought to the tavern later that same evening. Soldiers carried the coffin into the tavern and dragged it into the taproom on the right-front side of the building. John Parker would only tell Phyllis that the crate contained the body of an executed spy scheduled to be buried the following morning, and he made no mention of Dr. Byram.

Meanwhile, Phyllis had become worried about the uncharacteristic absence of her Dr. Byram. It is anyone's guess whether Phyllis overheard the conversation of the soldiers from her room, or had put together the fact that her love had been missing since the events of the night had begun to unfold. Perhaps, as lovers often do, Dr. Byram had shared his secret identity with Phyllis; for some reason, Phyllis decided to see for herself whose body was in the box. Later that night, Phyllis crept down the staircase, crossed the hall on the first floor and, before anyone could stop her, commenced to chop and tear at the nails on the lid of the coffin with a hatchet until the lid could be removed. What was heard next were the sounds of young Phyllis emitting horrifying shrieks and screams as she gazed at the distorted, mangled face and neck of her executed lover, only hours dead. There are no further mentions of a living, breathing Phyllis after this night, and it is said that the experience resulted in her going hopelessly and permanently insane.

Upon hearing of the terrible aftermath of the hanging, General Anthony Wayne thought better of the rushed trial and hanging, and issued orders

Former taproom where Phyllis was supposed to have pried open Dr. Byram's coffin. The orb in the upper left is an illuminated dust particle.

that the entire event should be kept quiet and not disseminated for public knowledge.

However, reports of the ghost of Phyllis Parker continue to this day in the building; accounts of isolated and occasional paranormal events seem to have begun in 1885, concentrated mostly during the winter months. In 1877, the former tavern was a private residence. On a January night of that year, presumably close to the one hundredth anniversary of the event, there was a mother in the home engaged in sewing in a first-floor room while her baby slept upstairs. No stories had been told of Phyllis up to this point in time, so there was no prior knowledge on the part of the mother as to what had supposedly occurred at the site.

While the woman was sewing, she heard men's footsteps on the porch, followed by the front door opening. The footsteps continued inside until she heard the thud of a heavy box being dropped on the floor of the family's dining room, the taproom of the former tavern and front room of the house. The sound of soldiers' footsteps then returned outside, followed by the sound of the door closing. Frozen in place by fear, the woman sat in silence until hearing lighter footsteps descend the stairs, cross the hall and enter her dining room. This was closely followed by the sound of rending

wood and someone trying to pull nails and open a strong box. At this point, the mother ran upstairs to comfort her baby who had begun to cry.

Suddenly, from her position in the second-floor baby's room, the mother heard the agonizing screams of a young woman rising up from the first floor, screams that slowly faded into unconsoled, grief-laded sobs and then silence. The mother, frightened beyond imagination, sunk into the bed in the upper room and awaited the return of her husband later that evening. The husband must have entered his home through another door, for it was later noted, upon the couple's inspection, that there was nothing out of place in their house, and the door through which the phantom footsteps entered and exited was still securely barred. Interestingly, the story began to circulate, soon after this experience, about the beautiful and tragic Phyllis and her doomed doctor/lover/Tory spy.

Since that time, this building that once housed the former Vealtown Tavern has served a variety of functions. Built in 1710, it became a private residence after its use as a tavern. During part of the nineteenth century, it was the place where Vealtown residents would receive and distribute mail that was brought in from Basking Ridge. During the Civil War, the affairs of the day were debated and news from the front was discussed in its parlors. There are even reports that the building served as a station for runaway slaves on the Underground Railroad. In 1902, the Bernardsville Library was incorporated and happily made its home in the building until it moved into its new location, just behind this site, in the year 2000. Most recently, the former tavern and library served as the offices of an interior design firm. At the time of this writing, the building is empty and awaiting its next incarnation. There are even rumors of it becoming a tavern or inn once again, perhaps even resurrecting its original name of the Vealtown Tavern.

Over the years, there have been numerous sightings of apparitions and reports of paranormal events in the building by very respectable people. Library employees working after hours have reported hearing children's voices in murmured conversation and a woman's voice softly singing from somewhere inside the library, but upon investigating every room in the building, no apparent cause could be found for these sounds. Doors were heard to open and close before business hours, and objects would sometimes move by themselves, especially in the staff kitchen area. There were also areas that gave people that uneasy feeling of being watched during the day and night. Given the amount of unexplained phenomena occurring in the building, it got to the point, during the library years, that the ghost was referred to as Phyllis, and the library actually issued Phyllis her own library card that was kept on file. In 1989, a three-year-old boy kept pointing into

Front room of the former Vealtown Tavern, directly across the hall from the taproom.

the reading room and asking his mother to come and look at someone. Upon gazing toward the place beside the fireplace where her son was pointing, the mother saw nothing, despite her son's insistence that he saw a beautiful lady in front of them with dark hair and a long, white dress that went down to her feet. The boy told his mother that he said hello to her, but she didn't respond to him.

Passersby would tell of seeing a woman in white inside the library's reading room, which, at one point, originally served as the structure's kitchen. The sightings were reported during the night and after the library was closed and the interior lit only by its night lights and exit signs. Furthermore, during the 1940s and 1950s, almost every member of the Bernardsville police force had an encounter with a woman in a long, white floor-length dress. One of these officers was former Police Chief John Maddaluna. In 1950, with his training sergeant, he was checking the locked doors of the library as a new recruit during the midnight shift. Officer Maddaluna shined his light inside the library and twice spotted a female figure in a long, white dress. When he informed his sergeant, Maddaluna was told not to worry, and that it was only the ghost, which the sergeant had already seen many times. When the woman's apparition was spotted by the police the first time, the

library director was called, the building opened and the entire site searched in vain. The building proved to be empty. Eventually, officers on the night shift began to park their police cars across from the library while on break, hoping to spot the ghostly figure of Phyllis.

During the building's tenure as an interior design firm, a variety of paranormal events were reported by the employees and the owner. During a meeting, one of the owner's earrings went flying across the room while the entire staff was having a meeting. Upon retrieving the earring, it happened again. At another time, a woman was once glimpsed in one of the rooms by an employee who was walking down the hallway. Upon going back to check, thinking the woman was a client, the room proved to be empty. Murmured conversation and singing were heard in the building with no apparent source. Soft footsteps, accompanied by a swishing sound similar to that of pant legs and the rustling of clothes, could be heard in different parts of the building late at night and before the doors were opened for daily business. Several times, employees on the second floor would hear the sound of someone coming in through the front door. Upon going downstairs, intending to help the customer, there would be nobody there. Sometimes, customers would try to leave but would not be able to open the door. When staff members went to assist them, it would be found that the deadbolt was locked, something that was only done by key at the end of the day. Often, items would go missing, only to show up at a later date in very unusual locations.

Several groups of paranormal researchers have investigated the building over the years, hoping to gather evidence of the haunting. An investigation in the 1980s succeeded in capturing EVP evidence. Using new, sealed tapes provided by reporters in attendance, the group met on January 29, 1987, an anniversary of the event, and captured the sounds of the movement of a heavy object being dragged, the tinkling of glasses, sounds consistent with a tavern and a voice that at one point says, "please." The tape can be obtained at the Bernardsville Library for listening.

On April 7, 1995, another investigation resulted in uneasy sensations being felt by two independent researchers at separate times in the same two aisles of books on the first and second floors. Later, infrared motion detectors picked up moving heat sources at these locations with no apparent cause. Also of note, during this investigation there was a camera malfunction that included the explosion of new alkaline batteries in the camera's strobe and the camera clicking off, in rapid-fire fashion, an entire roll of film on its own. While these incidents could be due to an internal problem with the camera or the batteries themselves, these types of events, while rare, have been documented at other sites during investigations. One of the accepted

theories is that entities draw energy from the batteries and electronic devices in order to manifest. In fact, during one of my visits to the former Vealtown Tavern, I had a set of new batteries completely drained, and I also found my new, spare set to be drained as well.

Most recently, in August of 2006, Garrett Husveth and a Haunted New Jersey group did an investigation using digital video recorders (DVRs) and digital audio recorders (DARs). The investigation took place in the evening and resulted in several, very distinct, Class A EVP voices being captured.

One consists of two male voices seemingly communicating with each other saying, "Say it!" and, "Sick with woe!" (see no. 10 in the Appendix), the latter a phrase particular to the eighteenth century.

A second EVP features a female voice saying, "Go, listen…Uh!"(see no. 11 in the Appendix). This seemed to be in response to an investigator who had just announced, "We're going to go listen now."

Still, a third EVP voice from this investigation features another female voice saying, "I'm down…in the wall" (see no. 12 in the Appendix). This is an odd expression. Could it be that someone, maybe even a passenger from the Underground Railroad, is buried beneath the dirt floor of the cellar, behind one of the cellar walls or at an undiscovered location on the property?

Additionally, there are interesting reports associated with the eighteenth-century house in Bernardsville where Byram's/Wilde's trial was supposedly held. Children and adults have seen the apparitions of a man and a woman, both in eighteenth-century clothing. While there is no further evidence to suggest who or what these apparitions might be, there is speculation, on the part of those that believe the classic tale, that they may be the ghosts of Aaron Wilde and Phyllis Parker. Unable to be united in life, could it be that they are united in death?

Now, having provided you with the historic background, the ghost story and the investigation results, let me go on to give you some more food for thought based upon a critical dissection of the story and the factual evidence. As chillingly romantic as the story is about Dr. Byram and Phyllis, I believe that it is no more than this—a wonderful, chillingly romantic yet *fabricated* story—a tale composed at a later date to explain and provide credence for all of the experiences. There are just too many inaccuracies and unsubstantiated accounts to verify the story as fact. This statement flies in the face of local lore, but I'll tell you the reasoning behind it.

First, human nature is such that we crave reasons for things. We want labels and we want explanations. The story about Phyllis, the Bernardsville Library Ghost, satisfies all of these basic needs. Anyone who has had a paranormal experience will tell you the part that was the most unnerving

was their inability to explain it. This story about Phyllis provides the phenomena a framework for comprehension, and it allows people to position the mysterious events in a manner that can be more easily accepted. Even though ghostly events are often classified as unexplainable, the ability to attribute events to a ghost—even one that, in this case, may have been fabricated one hundred years after the fact to justify more current events—is psychologically more comfortable than admitting we have no explanation for the phenomena.

Second, apart from this tale, there is no documented evidence of Phyllis having ever existed. Other than her mention in the ghost story, her name doesn't appear anywhere. There's no corroborating account of her working at the tavern, no mention of Captain Parker having Phyllis as a daughter, no grave—nothing. Her father, Captain John Parker, is buried beside the Basking Ridge Presbyterian Church, having passed away on March 4, 1781, at the age of thirty-three. His headstone, on the North Maple Avenue side of the church, marks his final resting place. Captain Parker had a wife and sons, all of whom are buried elsewhere, but there is no mention of a daughter. Furthermore, if Captain Parker was born in 1748, he would have been twenty-nine years old at the time of Wilde's hanging. This would mean John Parker would have had to marry at age twelve or thirteen in order to put Phyllis at sixteen years of age, her reported age in the story. Even if the ages of these two people are adjusted, it would make the possibility of marriage and/or courtship improbable for either John Parker or Phyllis.

Third, there is no hard evidence to substantiate the existence of Aaron Wilde, much less a Dr. Byram. Think about it. If a spy were to be captured, executed and presumably buried in your town, wouldn't it be discussed in conversation and documented somewhere else besides in a ghost story? The account would have been written, told and retold many times to the point when it would be common knowledge, yet nothing about Dr. Byram or Aaron Wilde appears anywhere in the space of one hundred years from 1777 to 1877—not in historical records, history books, the Library of Congress or National Historical Park records. After 1877, his name is only preserved in conjunction with this ghost story, a story that first appeared in print in the February 22, 1903 edition of the now-defunct *Newark Sunday News* newspaper.

Fourth, the article was written by a reporter whose sister also happened to be the woman who had the 1887 experience in the house. Notice how some of the sounds heard by the woman were described by the reporter. Must repetitive thuds be caused by footsteps? Can you tell the difference between a heavy box being dropped on the floor versus some other sizeable object? Are all heavy footsteps caused by men? Can you tell soldiers' footsteps apart

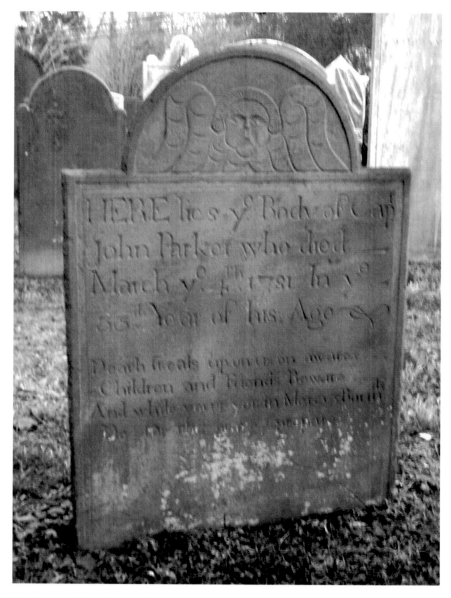

Headstone of Captain John Parker.

from other men's? Can you tell if the sound of pulled nails and breaking wood are coming from a box, implying a coffin, being forcibly opened, as opposed to any other wooden object? The answer to all of these questions is "no," yet the reporter described the woman as hearing men's footsteps, soldier's footsteps, a heavy box being dropped on the floor and the sound

of a box being ripped open. Why did the reporter do this? Well, it certainly would have built a case for a fabricated, entertaining ghost story!

Fifth, it would have been extremely unusual to find a beard on a man in the colonies during the 1770s. It just wasn't in style at all. The fact that Dr. Byram is said to have had a beard, supposedly to disguise his identity, is a red flag. A beard would have drawn more attention to him rather than less—not something a spy would want to do.

Sixth, Washington's troops only camped in Pluckemin January 4–5, 1777. Documentation at Morristown National Historical Park has the troops well established in their winter quarters in Morristown by early January. There is no reason why troops would be passing through Vealtown from a Pluckemin encampment, as the story suggests, at the end of January 1777.

Seventh, as a father, if I was in Captain Parker's shoes, knowing that my daughter was in love with Dr. Byram and already questioning his whereabouts, I would have made every effort to keep the coffin of the executed spy as far away from the tavern as possible, until it was interred the following day. The tavern, and right under the nose of Phyllis, was the last place I would have had it delivered so as not to arouse curiosity and invite investigation. And if, for some reason, the coffin had to be stored at the tavern, it would have made much more sense to store the spy's body overnight in the cool, uninhabited cellar instead of a public room on the first floor in front of a working fireplace.

Eighth, the mention of the whole event of Wilde's hanging being covered up at Anthony Wayne's orders, only to emerge in 1887, and well after Captain Parker and his family members had passed away, seems a bit too convenient. By the late 1800s, no one was left to refute the existence of Phyllis or Wilde, and anyone alive at that time would have immediately noticed that Wayne's part in this story was completely inaccurate.

Ninth and last, Anthony Wayne was promoted to the rank of colonel in 1776 and remained at this rank during January of 1777, meaning that he wasn't a general at the time this tale was supposed to have taken place. Furthermore, the story about Anthony Wayne's involvement in the Battle of Princeton and his presence at the Vealtown Tavern January 28–29, 1777, did not occur and just doesn't fit the historical documentation. In fact, there is no way that Anthony Wayne could have been anywhere near Princeton or Vealtown in January 1777 because Wayne was stationed in Fort Ticonderoga in upstate New York. It is three months too early for him to be in New Jersey according to military sources. The Wayne County Chamber of Commerce in Collinwood, Tennessee, and the book *George Washington's Generals* (New York: William Morrow and Company, 1964) both tell similar accounts. From the former:

In the spring of 1776, Wayne and his battalion went with the Pennsylvania brigade to reinforce the Canadian expedition, through which Congress had hoped to gain another colony for the American cause. By his personal bravery and leadership, Wayne held his troops together to cover the retreat of the entire American army after the defeat at Three Rivers on the St. Lawrence River. Congress abandoned the effort to win Canada, and Wayne was placed in command of Fort Ticonderoga. Here he had for the first time the thankless task of maintaining discipline among troops from various states who were disinclined to follow the orders of a Pennsylvania colonel. Commanding Fort Ticonderoga was not as enjoyable as his childhood game of fighting for it.

In February 1777, Anthony was made a brigadier general, and in April he left Ticonderoga to join Washington at Morristown, New Jersey, and take command of the famed Pennsylvania Line.

Adding to this body of evidence is a quote from Anthony Wayne himself that can be found in the book, *The Campaign of Princeton* (Princeton, New Jersey: Princeton University Press, 1948). "My heart bleeds for poor Washington," writes Wayne from Fort Ticonderoga, feeling frustrated and wishing he could be of more help to Washington. Remember that this entire story hinges on the idea that Aaron Wilde stole Anthony Wayne's papers. So, if there is no Anthony Wayne in Vealtown, there are no Wayne papers to be stolen, no spy to steal them, no spy to be executed, no body to be brought back to the tavern in a coffin and no need for any supposed daughter of Captain Parker's to pry off the lid of the coffin to see her lover's body inside the box, the sight of which causes her to go insane.

Now, understand that none of this is stated in any way to discount the paranormal reports at the building that once served as the Vealtown Tavern and the Bernardsville Library. I believe that people at the site have had paranormal experiences at this location. I believe the people who have said they have seen apparitions, heard noises and recorded EVP evidence. At this point in time, one can not prove that a location is haunted, but one can gather evidence, and I believe there is enough evidence to suggest that the former Bernardsville Library building can be classified as haunted. I believe there's a presence at the site. In fact, I believe there to be more than one. I just don't think, given the evidence to date, that we can say with certainty or credibility that any of them are the ghost of Phyllis Parker, a young woman driven insane by discovering her lover's hanged corpse in a coffin that she pried open on the bitter night of January 29, 1777, in her father's tavern.

However, that statement leaves us with the question: If it's not Phyllis, who is this apparition? Well, there's definitely evidence to suggest it's a woman.

It could be one of any number of people associated with the building going back to 1710. Also, consider that a good deal of the reported phenomena seems to be residual rather than intelligent, so it might be little more than energy that gets replayed from time to time. Additionally, the movement of objects could be due to poltergeist or psychokinesis.

There is EVP evidence to suggest that there may be both male and female entities at the site. Consider the information that both Garrett Husveth and I collected over several years at the former tavern. The more one reviews the evidence, the clearer the speculation becomes about the phenomena and the source and scope of the haunting.

Besides the three EVPs mentioned earlier in this story, we have both male and female voices that we recorded on digital audio recorders. The lack of tapes eliminates any chance of bleed-through or sounds that may not have been fully erased. Along with the male and female qualities to the voices that were captured on the following recordings, notice the correlation between the questions and the responses. Also take note of the location where the voices were recorded in regard to the responses.

Back room of the former Vealtown Tavern, directly across the hall from the taproom.

A female voice was recorded by Garrett in 2006 saying, "Tap it out" (see no. 13 in the Appendix) in the former taproom.

On one occasion, we asked, "Can you let us know who you are and if you were a soldier?" The two-word response was, "No. Yes."

We were interested in the way the entity may have perceived the surroundings, so we asked, "Do you see this room as a tavern or as a house?" The response we got was "house."

In the winter of 2007, I was upstairs in one of the former bedrooms while Garrett stood at the foot of the stairs. We were both recording, seeing if we could capture anomalous voices in two locations. What we got was not only the same response on both recorders, but the response mentioned me by name. I asked, "What year did you die?" A female voice whispered on Garrett's digital video and my digital audio, "Gordon, we don't die." This was the highlight of that particular night. It was definitely a Class C voice, but it was exciting to hear my name tossed back at me.

In one of the upstairs bedrooms is a very tiny closet, the corner of which reveals the exposed brick of one of the chimneys. This seemed like one of the areas that had not seen much change since the 1700s, so I decided to do an EVP session in there. While I was inside this closet, I asked, "Do you hide in this room? Do you stay in this room?" A male voice responded, "I'm stuck." On the next investigation date, I was in the bedroom near the same closet when I said, "There was a man's voice that I recorded in the closet that said, 'I'm stuck.'" Following this, we apparently captured the same male voice that said, "Just stuck" (see no. 9 in the Appendix).

Testing the theory we have about the fabrication of the Phyllis story, the question was posed, "Is your name Phyllis?" The response was an exasperated sounding sigh, almost as if the entity was entirely tired of being asked that question.

Sometimes the responses had an impatient quality, such as when we asked, "Please try to make a very...distinct sound." During the pause in the request, a man's voice says, "No." An hour later, I also stated, "Please talk into this device in my hand." A male voice was again heard to whisper, "No."

We also had a good deal of luck asking questions about the documented appearances of the female ghost. It almost seemed like we hit a nerve with these questions. On one occasion in the former taproom, we stated, "You showed yourself to a little boy and a police officer." A female voice affirmatively replied, "Mmm," as if it meant "yes." We also stated and asked, "You made yourself visible to a police officer in 1950. Can you make yourself visible to us?" This time the response was an unusual, short, growling sound. I think the appearances of these female apparitions may

have been meaningful because they earned a number of responses. Later, during a different investigation, we again stated and asked, "You manifested yourself to a police officer in 1950 and, later, a little boy. Is that true?" Following this question, a female voice said, "Mm-Hmm," as in "yes." Is it possible that the manifestations occurred to send people a message? Were they trying to tell the viewers something or lead them somewhere? Perhaps there is a secret or a discovery that still needs to be uncovered that keeps these entities grounded to this building.

As time went on, it seems our unseen friends at the former Vealtown Tavern were becoming familiar with us, and this familiarity, much like it does in life, brought additional communication. When the forced air heat turned on, we said, "If it's possible to speak louder now that the heater's on, that would be a huge help." Almost immediately after this, a male voice whispered, "Yeah."

One of the things we like to do is build upon previous responses. At one point, it was asked, "Are you stuck in the attic?" Soon afterward, a female voice was heard to say, "Mmm," with an inflection that indicated "yes."

From a historical standpoint, one of the most intriguing EVPs was recorded when we asked, "Can one of you leave us a name please?" In response, a male voice, which we heard later on the recording, whispered, "Yes." We then asked the entity to speak the name as loud as he or she could into the recorder. Just after this, a female whispered, "Hope." We are currently trying to find a possible connection between the site and someone named Hope. Alternatively, the response could also mean that we should keep hoping for a name.

During one of the sessions, I was in the balconied upper room. I had decided to go for more of an emotional reaction at one point when I said, "Workers are going to come in here soon. They're going to change this place." Before I went on to ask our unseen friends how they felt about that, a male voice chimed in with the word "No" (see no. 8 in the Appendix).

Capping off our hypothesis about the Phyllis story, we once asked the very direct question: "Was Elizabeth Parker your mother?" Consistent with my belief, a female voice whispers "No."

In conclusion, where does all of this leave us? What's the real story behind this haunting and this ghostly phenomena? While the story of Phyllis may have run its course, the collected evidence points to an even more exciting situation. Based upon EVP evidence alone, there seems to be more than one presence in the former tavern. There is at least one male presence, perhaps a soldier, and one female presence, whose name may be Hope. A male entity has expressed that he is "sick with woe" and perhaps "stuck" in the structure. A female entity stated she was "down in the wall." Some

Balcony on the second floor of the former tavern where one of the EVP sessions took place.

of them know the place as a tavern and some as a house. At least one of these unseen entities apparently does not want additional work to be done on the building, but these unseen beings are willing to communicate and, on occasion, manifest for certain people. One of their responses even indicates that we live on after this life.

Many questions remain. Who were these individuals? Were they escaping slaves, Continental soldiers, eighteenth-century barmaids or former owners or residents of the building? There is room for more investigation, to be sure, and each piece of evidence, if collected in a reliable manner, fills in another piece of the puzzle. For individuals that are willing to search, there are certainly many mysteries that are still waiting to be solved at the former Vealtown Tavern.

Chapter 3

THE NEW JERSEY BRIGADE SITE AND HARDSCRABBLE ROAD

In culture after culture, people believe that the soul lives on after death, that rituals can change the physical world and divine the truth, and that illness and misfortune are caused and alleviated by spirits, ghosts, saints…and gods.
– *Steven Pinker,* How the Mind Works

If the passage of time in any given location mixes long enough with the life-and-death struggles of men and women, some of those souls are bound to remain to cast their shadows on the future. There are a few unique places that, having endured the repeated ebb and flow of human activity, have managed to escape permanent development and return to woodlands. When these sites are found, they hold clues to its use left behind by the inhabitants. The earth and rocks often betray history, and imprinted in the very land and stones themselves are the ghosts of our ancestors.

A place such as this can be found in Bernardsville along Hardscrabble Road, especially between its intersections with Old Army and Jockey Hollow Roads. Although it is now spacious and wooded, this one-mile stretch of serpentine roadway threads its way through land that has supported human use going back to prehistoric times, well before the arrival of the Europeans. This area has been used in a variety of ways, supporting both the living and the dead.

After the Wisconsin Glacier retreated approximately ten thousand years ago, it left the environment strewn with massive boulders, the oldest exposed rock in the eastern United States. The smaller-sized granite stones proved to be useful as a readily available construction material, although it was despised by the local farmers who needed to clear it from the hillside for sheep grazing. The clearing resulted in stone rows that are still visible in the woods. However, upon first impression, one can not help but be impressed with the sheer size of the larger rocks, especially those found at the top

of the hill on the northern side of the road. The groupings of SUV-sized boulders seem to give the area meaning, an impression that was not lost on the first people to view them.

The earliest humans to use this area were members of the Lenape tribe, a name meaning "common" or "original," and this hillside was sacred to them. The Lenapes were peaceful people with advanced agricultural skills, and they cultivated much of what they ate. These foods included many types we still enjoy today, such as squash, beans, corn and pumpkins. There were two confirmed settlements in the vicinity, and at least one source mentions that these people had a written language, an extremely unusual and advanced achievement.

The Lenapes also had a monotheistic society that believed in one god and in the immortality of life. Upon death, several interesting cultural beliefs and practices were observed. Before the arrival of Europeans, Lenape funeral customs included burying the corpses in fetal positions and in shallow graves. European influences were later adopted, and the Lenape began to lay out the bodies in an extended fashion, although the depth of the graves continued to be very shallow. One custom that never changed was the inclusion of a package of food in the grave to serve as sustenance for

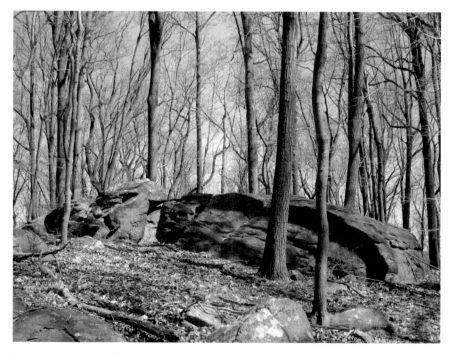

Boulders on the site of a Lenape burial ground.

the spirit on its journey into the next life. Sheets of bark covered the bodies, but this later gave way to the use of wooden coffins. These coffins had a hole cut into the head of the coffin and painted red to act as a portal for the soul. The graves of males were marked by diamond-headed wooden posts. Diamond-pointed wooden crosses marked the graves of females.

The Lenapes believed that souls embarked on a twelve-year journey to the twelfth heaven, where they lived without pain, sorrow or sickness with their god Kishelëmukòng. Once buried, no one in the tribe ever spoke the name of the deceased again. This was done so that sorrow was not aroused in the surviving family members. It also helped guarantee that the soul would not hear its name and perhaps return to earth or pause on its journey.

Along the bottom and southern edge of this hillside, you will notice a winding stream that runs on both sides of Hardscrabble Road. This pristine piece of water is known as Indian Graves Brook. It is today a very quiet and shaded waterway that bears witness to the status of the hillside that looms above it. The Lenape dead were buried relatively close to the settlements, and this hillside was the area chosen by the Lenapes as their burial ground. The area is now owned by the National Park Service and the Audubon Society. Several trails cut through this wooded area, passing underneath oak and beech trees, beside granite boulders and over a land that harbors long-forgotten graves. I have always felt a sense of melancholy that stretches from the western flank, across the crest of the hill and east to where Indian Graves Brook meets the Passaic River. A presence can be felt in this region, one that is watching and aware of the movement of visitors, almost as if it is guarding the area. I am far from the only one to sense this. Over the years, I have been given the same reports from residents, hikers and those that explore the banks of the Passaic where it cuts through the Audubon sanctuary. All of these people have reported a feeling of being watched, a feeling that varies in intensity without betraying a source. Take a walk in the twilight beside the Passaic River or amidst the boulders on the crest of the hill, and you will understand what these people are feeling. Whether you sense it behind you or beside you, the presence can be almost palpable as you feel it observing you and monitoring your progress. This is an incredibly beautiful area, but make no mistake—this is hallowed and haunted ground.

The early eighteenth century brought new people to these woods. Near the very top of this hill are large cuts, pits and gullies in the earth. Upon first sight they are puzzling, because they are not congruent with the surrounding slope of the land. This is because they are the remnants of another completely different use of this area and its resources. From as early as 1723—when a fulling and textile mill was established along Hardscrabble

Road—to the mid-1800s, this area along the brook was known as Logtown, due to the piles of logs that were brought in to be processed at the area's sawmills.

Early Logtown residents included farmers who came to this little valley to raise sheep for their wool and flax for the textile mill. Through those years, Logtown included three sawmills, a carpet-weaving shop, a gristmill, a general store that also served as a Revolutionary War commissary, mechanics' shops, a fulling mill, a blacksmith's shop and a forge. Ayers's Forge, dating back to the 1700s, was located on the eastern side of the Passaic River, just a few hundred yards southeast of where Old Army Road meets Hardscrabble Road. The old Forge Road once ran in a northerly direction from this same intersection and no longer exists, but one can still trace its former path through the Scherman-Hoffman Wildlife Sanctuary and northward beside the Passaic River.

It was during the eighteenth century that some exploratory pits, gullies and cuts were made on the Logtown hillside to mine iron ore. The ore was dug largely by hand and loaded into carts where it was then taken to local furnaces. The resulting iron produced by these furnaces was used by blacksmith shops, including one that used to be located just across from

Mining gully in the Hardscrabble hills dating from the eighteenth century.

the entrance to the old Forge Road. As time passed, the industrious nature of the Logtown settlement gradually dissolved, and the name gave way to Hardscrabble.

Perhaps some of the unsettling vibrations I have felt on the hillside above Indian Graves Brook have another explanation. Several yards up the spur trail of Patriots' Path off of Hardscrabble Road lies another historical point of interest, for it was on this spot that General Washington's New Jersey's Seventh Brigade built their huts during the Revolutionary War.

During the winter of 1779–80, General George Washington had his army encamped in the Logtown and Jockey Hollow areas while he made his headquarters in Morristown. For his troops, this particular winter was the most severe and ferocious of the entire Revolutionary War, due to its heavy snows, bitterly cold temperatures and frigid winds. In fact, the temperatures during the month of January 1780 climbed above zero degrees only once. Interestingly, one of the reasons why the Valley Forge, Pennsylvania, encampment is better known has much to do with the fact that approximately three thousand men died from the conditions there. This was primarily due to disease, as compared to Jockey Hollow, where the official death total was just over one hundred. The death toll would have been higher at Logtown and Jockey Hollow had the soldiers not been inoculated against smallpox and better informed about camp sanitation.

Still, the conditions were extremely poor for the soldiers in New Jersey. With no less than twenty-eight snowstorms occurring during this area's worst winter of the century, up to four feet of snow on the ground and drifts over six feet deep blocking supply roads, the men did their best to provide themselves with shelter and food and preserve their torn coats and tattered clothing. As one can imagine, food supplies dwindled, and the New Jersey Brigade—forced at times to eat tree bark to survive and sleep on beds of loose straw and often with only one blanket per three men—faced starvation, disease, exposure and their share of death. Somewhere in the area are even the graves of two officers among those of the other men who did not survive the winter.

Logtown actually had a commissary that sold supplies to the troops, but the buckles, shoes, belts and other equipment from this establishment were procured mostly by officers. The commissary was located in what is now a beautifully restored private home, known today as the Reynolds-Scherman House. Built of fieldstone in 1750, it graces the intersection of Hardscrabble Road and Chestnut Avenue. Originally built for Samuel Reynolds, it was later owned by the Scherman family from 1921 to 1981. Mr. Scherman was the founder of the Book-of-the-Month Club, and the house was used for entertaining many notable authors and celebrities in the

summers and on weekends. The Logtown area actually retains much of its charm due to Mr. and Mrs. Harry Scherman, who, in 1965, donated land for both the preservation of the New Jersey Brigade site and the beginning of the neighboring Scherman-Hoffman Wildlife Sanctuary.

During December of 1779, more than one thousand simple log huts were erected by Washington's soldiers from the surrounding six hundred acres of timber. Each hut was built to a standard size of sixteen feet long by fourteen feet wide, with a peaked roof over walls measuring seven feet high at the eaves. Each hut also contained a stone hearth and chimney where fires were tended for cooking and to provide warmth. Approximately seventy-five of these huts were erected on this very hillside along Hardscrabble Road by the New Jersey Brigade, commanded by Brigadier General William Maxwell.

Arriving at Elisha Ayers's forge, a site very close to the eastern end of Old Army Road, and setting camp just north of this spot in Ayers's Field, the troops began construction of their shelters on December 17, and the men moved into their primitive huts on Christmas Day. If you follow the signs on Patriots' Path you will soon see the site of one of these huts. The area is now part of Morristown National Historical Park, yet it is seldom visited as it is a walk-in site only. However, it provides one of the most direct points of contact with actual, physical structures from the Revolutionary War. Set among the trees are the stones of an original hearth that once contained the fires of soldiers over 228 years ago at the time of this writing. It is fairly easy to see where the walls were at this site and get a sense of the cramped living conditions that once existed here.

I would like to add that all of the area in this valley along Hardscrabble Road and Indian Graves Brook—stretching westward from the Old Army Road intersection up to Washington Corner Road and also northward up the Passaic River from the Old Army Road intersection and into Mendham—came very close to being completely obliterated. The people that use, enjoy and have homes in the area will forever owe an enormous debt of gratitude to Fred Bartenstein Jr. and his wife Isabel. As residents of the area, their tireless efforts in 1967 served to initiate a search by archaeologists to conclude and verify that the New Jersey Brigade's encampment site had been located. This discovery halted a plan by the State of New Jersey to build a massive water-storage reservoir in the valley. The dam itself would have been located just east of where Old Army Road meets Hardscrabble. Had the dam been built, it would have held back twenty billion gallons of water, most of it piped in from the Delaware River. Collected, it would have filled the valley nearly all the way to Mendham, inundated twelve hundred acres and required the condemnation of twelve hundred additional acres along the edges of the proposed area. In short, this

highly historic, stunningly verdant and environmentally sensitive area would have been wiped off the map. Hats off to the Bartensteins! They are, in my eyes, the saviors of this valley.

The efforts of the Bartensteins also preserved much more than we can see. Several ghosts are also said to roam and inhabit this secluded, wooded valley. The following descriptions will give you a clear insight into the variety of apparitions that have been reported over the years.

THE SPECTER OF THE NEW JERSEY SEVENTH BRIGADE SOLDIER

The houses on this section of Hardscrabble Road have a guardian, or at least a watcher, who paces the hillside. He has been seen by several people. Hikers on the National Park trails and the paths of the Audubon sanctuary have caught glimpses of him from time to time, and residents of the area have seen him as well. To be sure, catching sight of this man is a rarity; but when it occurs, it is memorable, for he is not your average outdoorsman.

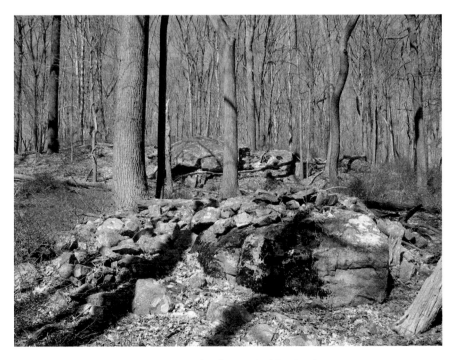

Stones on the hillside where the ghost of a Colonial soldier has been seen.

He has always been seen from a distance, and he is reported to be dressed like a Continental soldier. Witnesses describe a man in a blue coat wearing a tricorne hat on his head. The specter seems to be carrying something in his hands, but it is inconclusive whether it is a rifle, tool or something else. Once seen, the soldier never lingers. He either continues walking at a quick pace through the woods until disappearing in the trees, or he vanishes at his position before he can be approached.

Local belief holds that this man was once a member of the New Jersey Seventh Brigade that endured the harsh winter of 1779–80 in their huts on the side of this hill. If this entity is the ghost of one of New Jersey Brigade soldiers, is it possible that he could be contacted?

While this appears to have the qualities of a residual haunting, there is the sense that this entity is aware of those that sight or approach him and disappears before they get too close. At the end of this chapter, we will review the evidence that suggests more of an intelligent element into this spirit.

THE HARDSCRABBLE GHOST

There are many old houses that sit on Hardscrabble Road in the area once called Logtown. Some date back to the early 1700s. These houses have seen their share of history, so it's no wonder that some of them are reputed to be haunted. In fact, one longtime resident of Hardscrabble Road once said to me: "You can ask anyone on this road about ghosts, and they'll probably have a story to tell you about their own home." One such house claims to have an apparition that has come to be known as the Hardscrabble Ghost, an entity that not only likes to make appearances but throw things as well!

As it was told to me, one evening there was a dinner party being hosted by the homeowners for a group of their friends. Everyone had arrived, and things were going as planned, but there was an unseen guest who was in attendance that night. As the meal was being served, an invisible force removed a fork from the hand of one of the guests and sent it darting across the dining room table. What's more, while the fork was in midflight, it changed direction, flying off at a sharp angle until it hit the front door, where it finally came to rest on the floor. "What just happened?" the startled diner asked. The rest of the guests had all seen the event, yet none could offer a reasonable explanation. Minutes later, the hostess walked into the kitchen only to be welcomed by a cup that flew across the room, right before her eyes, and came to rest on the cutting board in the breakfast room. No one had thrown the cup, and the unnerved guests were then at a total loss

The Reynolds-Scherman House, circa 1750, and former Revolutionary War commissary on Hardscrabble Road.

for words. These were not isolated events experienced by one individual. On the contrary, these unexplained phenomena occurred within a very short time of each other and were witnessed by a house full of people.

As if this were not enough, two people have seen an apparition in this same home as well. On several independent occasions, a blue, misty shape has been seen hovering in one of the interior doorways. Both witnesses report that it resembles a human in stature and proportion but is not solid, and it appears to be slumped in a sitting position between the doorway and the kitchen pass-through. There also seems to be an agreement as to what this apparition is and what causes the phenomenon to occur. Knowing the area's history, those that have experienced the sightings and the other phenomena believe it to be the spirit of a Revolutionary War soldier. Many of them were camped in the area during the brutal and snowy winter of 1779–80, and many of them did not survive to see the spring due to disease, starvation and exposure. While the facts state that many of these soldiers died at Logtown, it is possible that some of these American Patriots are still on active duty.

The Woman of the Old Forge Road

The remnants of the old Forge Road can still be seen in the Audubon sanctuary off Hardscrabble Road, barely suggesting its original, northerly route toward what is now the Jockey Hollow section of Morristown National Historical Park. By day, the shadows hang thick under the trees that tower above this old path once traveled by millworkers and forge workers, Logtown residents and Revolutionary War soldiers. By nightfall, the murky depths are clothed in silence, intermittently disturbed by the chatter of night creatures and the voice of the Passaic River. It is not uncommon to see deer, fox and other wildlife moving through these woods, but throughout the years there are other visions that have been reported as well, sightings that are not so easily explained.

Reports have long been made about a woman in a bonnet, wearing a long, white, full skirt and carrying a lantern or a bucket along the route of this old road. Passing slowly through the woods, she has been seen by various people, only to disappear behind trees, leaving behind no trace of her presence. Who could this wandering apparition be? Perhaps it might be more accurate to ask who she might have been.

The former route of the old Forge Road where the ghost of the Camp Follower Woman has been sighted.

She has been called the Walking Woman; the Angel of Mercy of Old Forge Road; and the Camp Follower Woman. Many people believe her to be the ghost of a resident who once carried water or food along the route, perhaps assisting the Revolutionary War soldiers who struggled to survive the harsh winter when they camped in the area. Another suggestion is that she is related to one of soldiers from the 1779–80 encampment, a time when wives and other female relatives would follow their men from site to site. Others suggest she was a resident worker whose spirit still performs the chores she did in life. Whoever or whatever this apparition is, she has been seen since the late 1700s and never wanders very far from the route of the all-but-forgotten Forge Road.

All of the sightings of this ghostly figure suggest that it has the qualities of a classic residual haunting. The entity never leaves the area, and she never interacts with or acknowledges those that are fortunate enough to see her. If this is the case, then we need not feel concern for this disembodied entity. It is more than likely that the sightings are only perceptions of energy from the past that is replaying itself over and over again.

THE WOUNDED SOLDIER

Old Army Road, as the name suggests, was the route once used by Washington's troops to travel between their Jockey Hollow encampment and the Vealtown Tavern in what is now Bernardsville. Climbing up a steep slope from its beginning at Hardscrabble Road, it meanders through mature woods and snakes around a hairpin turn where, in the winter, one can look down on the bucolic valley that used to be busy with soldiers, millers, farmers and sheep.

From time to time, drivers at night have reported seeing the alarming sight of a wounded young man in their headlights. He appears to be quite real and is described as having light brown hair, tan or brown pants and boots and he is very similar in appearance to a soldier from the Revolutionary War. Looking to be in excruciating pain, he is sighted along the roadside clutching his side, where his white shirt appears to be covered in blood. Seen on this road and at some other places in the vicinity, this apparition simply vanishes in front of the viewers' eyes, but he looks so real that some people have called an ambulance, thinking that the man had been involved in an automobile accident. Of course, when people have stopped their cars and mounted an effort to find him, there is never any remaining trace to be found of his presence.

Old Army Road, one of the sites where the ghost of a wounded Colonial soldier has been reported.

This, again, seems to be a sighting that displays the quality of a place memory haunting.

New Evidence

For all these stories, one would think that there might be some evidence collected over the years that could be used to back up the ghostly tales. Unfortunately, none of these ghosts appear on a regular basis, and when they do, they are fleeting. What's more, the timings of their appearances are so ephemeral that they don't make themselves good candidates for being recorded on film. The best personal experience we have is the group sighting of the flying-fork phenomenon. Whenever you get more than one person corroborating the same story, it lends an added dimension of substance to a report.

Not until this book has anyone attempted to collect forensic, audio evidence of any of these spirits, so the material I will be presenting is breaking new ground in the documentation of these stories.

Obviously, the most accessible locations of the ones listed in this chapter are the ones that are located outdoors in public locations. Seizing this opportunity, Garrett Husveth and I set about recording and collecting EVPs at the New Jersey Brigade's 1779–80 winter encampment site and the field a half-mile away, where the brigade tented for two weeks during December of 1779 while they built their huts. Our results proved to be most interesting.

First of all, let me say that the recording conditions in this area are challenging. As secluded as this wooded valley may seem, it is inundated with commercial air traffic. There seems to be a perpetual line of jets that soar along the length of Hardscrabble Road, so we were often forced to wait until the sound of the engines subsided. At the very moment it seems quiet enough to record, another jet would begin to fill the air with its own thunder. Add to this the sounds of nature that came from all around us and you have a perfect storm of background noise that offered precious few periods of silence. This seems odd when one considers that we were, after all, in an Audubon sanctuary and a national park. Even when recording at night, when the planes seemed to be less frequent, there were the constant trills of crickets and katydids in the autumn air.

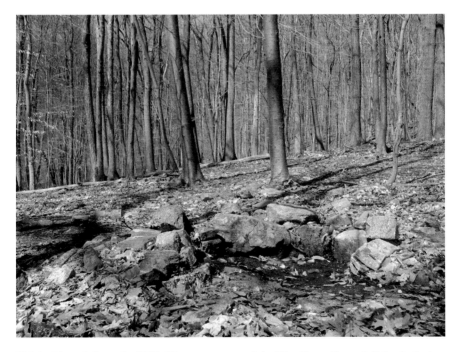

Original hearth from the 1779–80 encampment of the New Jersey Seventh Brigade during the Revolutionary War.

We were, however, undaunted in our attempts to do our work, and our persistence and patience to find quiet times in these woods paid off in the end. All of our recordings were done with digital voice recorders, sometimes with digital video recorders employed as a control. I alternated between doing sessions where I held the recorder in my hand and others where I placed the recorder on my soft backpack so as not to pick up the sound of my own breaths. During all of the sessions, we remained absolutely still and noted, in a loud voice, any sounds that we heard and could possibly be misconstrued as something out of the ordinary.

My first EVP "hit" in the New Jersey Brigade area captured the sound of footsteps along with metal and wood clanking together during a time in my questioning when I was making no movement whatsoever (see no. 14 in the Appendix). In fact, this recording followed a point in the recording where I had just mentioned feeling a cold chill go through my body. Another recording at the same area featured me asking if the entity was a Continental soldier. After a few seconds, a reply came in the form of a man's whisper that was heard to say, "Yes, sir." Using this information, I tried to build upon this evidence and ask questions that would further reveal something about this man. During one of my follow-up EVP sessions in the area, I simply asked the question: "What was the manner of your death." When I got home to analyze the recording on my computer, I was excited to hear a male voice responding with the whispered words of "The winter." Knowing that the winter of 1779–80 has been described as the most brutal winter of the entire eighteenth century for this area, this response was very much in keeping with historical records.

It's exciting to be investigating an area for the first time. While I was hopeful that the recordings would result in something tangible, I had no idea how long it would take or what kind of voices would be recorded. Bear in mind that the results reported in this book are only a beginning. How many entities are willing to communicate? What are their names? What time period do they represent? The Hardscrabble Road area is strikingly beautiful, but there is more here than meets the eye. As time goes on, perhaps additional EVP recordings will shed additional light on the entities that move through these shadowed woods.

Chapter 4

THE GRAIN HOUSE

I think a Person who is thus terrify'd with the Imagination of Ghosts and Spectres
much more reasonable than one who, contrary to the Reports of all Historians sacred
and prophane, ancient and modern, and to the Traditions of all Nations, thinks the
Appearance of Spirits fabulous and groundless.
– Joseph Addison, The Spectator, *July 6, 1711*

At the intersection of Childs Road, Morristown Road (Route 202) and North Maple Avenue in Basking Ridge is an area known as Franklin Corners. At the heart of this area sits a cluster of buildings that represent a full, rich history of service to the area and our country's Revolutionary War troops. The centerpiece of these buildings is the former Van Dorn Mill, an incredibly well-built structure that stands as, arguably, one of the finest examples of masonry in New Jersey. It is flanked on the left by the house that was once the homestead of the Van Dorn family. To the old mill's right and across Route 202 stands the old Van Dorn barn, a building that was once known as the Old Mill Inn but now carries the name of The Grain House Restaurant.

In 1768, an early miller by the name of Samuel Lewis, who resided in the Franklin Corners area of Basking Ridge, built a barn and a water-powered gristmill on the Passaic River. The land on which they were built was originally acquired from William Penn. Lewis's grandson, Richard Southard, later went on to purchase his grandfather's farm in 1777. When the Revolutionary War occurred, this original wooden mill supplied flour, cornmeal and feed to Washington's Continental army when they camped at Jockey Hollow and in Morristown during the winters of 1777–78 and 1779–80. The barn was used to store the army's supplies, the majority of it being grain, which is why it is known today as "The Grain House."

Vintage photograph of the Van Dorn homestead and the stone mill. *Courtesy of the Historical Society of the Somerset Hills.*

After the war, Samuel Woodward, another family member, assumed ownership until 1841. His daughter Phebe married Ferdinand Van Dorn, a miller from Peapack, who later bought the property. Ferdinand Van Dorn found the old wooden mill to be unsatisfactory, so he designed and constructed a replacement. In 1842, he erected a larger stone mill with an internal waterwheel system. This is the stone building that still stands between Childs Road and Morristown Road and is located opposite the restaurant.

It is said that the excavation for the cellar was accomplished by a "tramp" who was passing through the area and worked through the winter for bed and board. Several thousand loads of stone were brought to the site, their source being the hedgerows of farms along Hardscrabble Road. The foundations of the stone mill are supposed to be massive, extending twenty feet below the ground, and its walls range from seven to nine feet thick. The walls of the basement and other stories range from four to two feet in thickness, and each of the fifty windows is fitted with a keystone. While the entire mill was built for about $5,000, it paid for itself within the first year of operation.

The business part of this type of mill is the pair of millstones themselves, which were actually fashioned from separate blocks of buhrstone imported from France. Buhrstone is a tough, silicified limestone, and it is typified by the presence of multiple cavities that originally housed fossilized shells. These individual buhrstones were cemented together and bound with iron hoops. With the lower millstone set in place in the floor, it was the

Current view of the former Van Dorn home, now a private residence.

upper millstone that revolved, turned by the mill's machinery, without ever touching its lower counterpart. The grain was sheared and then pulverized by the furrows cut into the faces of the two millstones (the furrows acted much like the blades of scissors when the upper millstone turned). The resulting ground grain and flour was of a very high quality and considered some of the best produced in the area.

Eventually, the property passed through the ownership of William Van Dorn, Ferdinand's son, and S.S. Swaim, and it was later owned by Messrs. Ingersol and Eames. During the ensuing years, the mill gradually fell into disrepair, but the buildings eventually received a new lease on life. William Childs, for whom the road is now named, bought the entire property outright in 1929. He moved the old Southard barn the following year from its original location directly beside the stone mill to its current resting spot just east and across Morristown Road and began converting it into the Old Mill Inn, a restaurant with rooms for overnight guests. The mill continued to make flour and cornmeal for a local bakery until the early 1940s. Many of the Van Dorn family members are interred in Basking Ridge's Evergreen Cemetery, where their family tombstone is topped with four millstones.

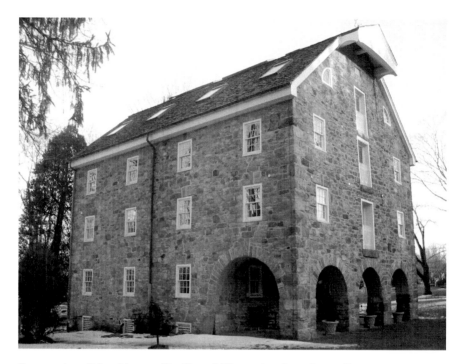

Current view of the old, stone Van Dorn Mill, now housing private offices.

The former Southard barn and Old Mill Inn is actually the site that is associated with the most paranormal activity. As stated, this building once served as the barn for the Van Dorn family before being moved by William Childs. However, rather than gut the inside, Childs chose to preserve the classic old structure's unique history through a painstaking restoration. Not a beam was touched in the barn's solid frame, and it remains to this day as it was more than two centuries ago. The uses of the rooms are the only things that have changed, and the haylofts and horse stalls now have other uses. What was the wagon and machinery room is now the William Childs Dining Room. The grain storage area that fed Washington's army is now the Grain Room. The horse stable is the Coppertop Pub and the bents in the second floor's great haymow are now offices and meeting rooms. The restaurant retained the name of the Old Mill Inn until 1977. Today, the establishment has been renamed The Grain House Restaurant, with a new hotel just across its parking lot carrying on the name of the Olde Mill Inn, albeit with a slight modification in the spelling. However, while guests may dine at The Grain House, there are many people who feel that there are several unseen guests that haunt the building and the surrounding area.

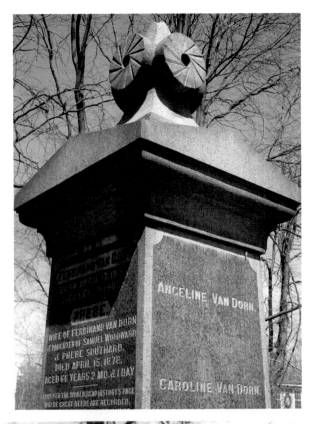

Right: The Van Dorn family headstone crowned with four millstones.

Below: Vintage photograph of the stone mill and the Southard barn, now the Grain House Restaurant, before the barn was moved across Morristown Road. *Courtesy of the Historical Society of the Somerset Hills.*

Sometimes, it is fairly easy to attribute a portion of the reported phenomena to an overactive imagination. At other times, you have to ask yourself the question: "What came first—the ghost or the photograph?" For example, there is a modern-day story circulating around the area about a phantom carriage that appeared only once to a group of people on the curve on Childs Road, just in front of the stone Van Dorn Mill. According to the story, a fully-staffed, horse-pulled carriage appears along the road and slows to pick up a woman with dark hair, an elegant hat and a long white dress. After the woman is seen to climb aboard, the coach is said to vanish into thin air. Interestingly, there is a photo of this exact scene that can be found in the local historical society. Is the sighting possible? Well, there is always the chance that it could be residual energy, so it would be close-minded to rule the sighting out completely, but healthy skepticism is a valuable tool for anyone investigating paranormal events. In this case, I would be inclined to think that the photo came before the reported sighting. This is an important point, and, when this is weighed in conjunction with the fact that this photo has been published from time to time, it makes it more plausible to think that this sighting was more the result of people's romantic imagination than it was caused by actual ghostly phenomena.

Vintage photograph of a carriage in front of the Van Dorn Mill on Childs Road. Could this have been the inspiration for a ghost story? *Courtesy of the Historical Society of the Somerset Hills.*

During the Civil War, one of the routes of the Underground Railroad ran through the Basking Ridge area, having passed though a switch (a fork in the route) that is known to have existed at the Passaic River Gorge in the neighboring town of Millington. The old barn is thought to have been a station on the route, and fleeing slaves are thought to have found sanctuary behind its hand-hewn, timbered walls. One of the ghosts is believed to be named Justin, a freed slave who participated in the Underground Railroad. He has reportedly been seen with the apparition of another man leading figures through the woods on moonlit nights.

Within the walls of the restaurant, strange tapping sounds have been heard and inexplicable events occur to this day. Some workers attribute these phenomena to the ghost of a former caretaker named George from the mid-eighteenth century. It seems that George was once promised ownership of the property, but the deal never came to fruition. It is said that it is George's spirit that still roams the old restaurant, especially the kitchen area, where he makes his presence known by rattling pots and pans. It is also thought to be George that plays with the water and the lights. Very late at night, lone kitchen workers will leave the kitchen in darkness while on their way to get their coats, only to find the lights lit when they come back down the hall. On other occasions, members of the staff will find the water running in the morning upon opening. "There is a presence that I feel in the back of the hallway," remarked one worker, "that makes me feel very uncomfortable. Sometimes, when I check the alarms at night, I can't get out of the place quick enough. I'm not one to buy in to these types of stories, but there's something here that lets me know I'm not alone."

There are still other ghosts that have surprised people in the restaurant. On at least one occasion, one of the restaurant's staff was headed to the room at the far end of the upstairs hallway. Upon entering the room, she reported seeing a Continental soldier putting on his boots. When the soldier's apparition stood up, it simply vanished. The identity of this soldier remains a mystery to this day.

There are also reasons to believe that one of the ghosts in The Grain House may be that of a little girl. On one occasion, two women were cleaning the restaurant early in the morning. For the sake of the story, we'll call them Amanda and Julie. The two women were separated—Julie was upstairs and Amanda was working on the first floor. At one point, Amanda passed the doorway to the main dining room that is just across from the pub. As she glanced into the large room, she spotted a little girl running and skipping in between the tables by the fireplace, appearing as if she was playing some kind of a game. The girl looked so lifelike that the woman assumed that Julie must have brought her daughter to work with her. Upon meeting up with

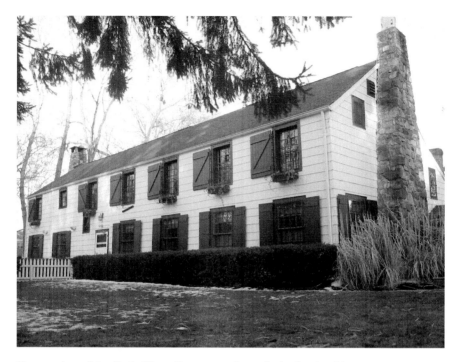

Current view of the Grain House Restaurant, formerly the Southard barn.

her coworker, Amanda remarked how much fun Julie's daughter seemed to be having in the dining room. Imagine the surprise she got when Julie told her that her daughter had not accompanied her to work. An ensuing search of the building, which was still locked to the public, turned up no children at all. In fact, there were no other people in the restaurant.

On another occasion, one of the managers was upstairs in his office, situated in one of rooms that used to be a bent in the old haymow. The restaurant was quiet toward the end of the evening when a sound caught his ear. It sounded like a child giggling in the hallway outside his office. Thinking this to be odd, he went to investigate the source of the sound. Looking out of his office door, he saw no one in the hallway. Investigating further, he checked the stairs and then all of the other rooms on the second floor. He found nothing out of the ordinary and no sign of any other people. Resigning himself to thinking he had imagined the giggling sound, the manager returned down the hallway to his office. When he stepped inside, he got the surprise of his life. Consistent with many offices I've seen, there are often a couple piles of paper that accumulate on desktops during the course of a week. This office was no different, yet when the manager stepped into his office, an entire stack of his papers was falling through the air and settling

on the desk and floor, as if unseen hands had just thrown them up into the air. Was this the result of a prank played by the phantom child?

In response to these two events, it's interesting to note that there is a report that surfaced during the research for this book, coming from a relative of one of the former owners of the building. Apparently there was a twelve-year-old girl that died tragically in the hayloft when the building was still used as a barn. This leads us to question whether the apparition of a girl, the child's giggling and/or the tossed papers could have any correlation with the death of this girl.

Another interesting story concerns a series of events that have played themselves out several times at the restaurant. As is the case with many establishments, there are motion detectors installed in all rooms and on every floor of the restaurant for security purposes. Four or five times, these detectors have tripped the alarms. The alarm company notifies the police whenever the sensors are tripped, and the police always find the same situation when they respond—the entire building is secure. Doors and windows are locked, and nobody is ever found inside the restaurant. However, I've saved the best part of this story for last. The protocol established by the alarm company includes making a telephone call to the restaurant whenever the alarm sounds. This allows for human error, just in case someone from The Grain House should enter and begin moving around the building without disarming the alarm. Nevertheless, the interesting part about these events from a paranormal perspective is that the sensors always go off in the same sequence. The first to be triggered is the one in the upper hallway, where the old hayloft doors are located. Next to be tripped is the one on the stairs leading down to the main floor. This is followed by the lower hallway motion sensor, the main dining room, the pub and finally the sensors in the kitchen area. It's worth mentioning that the sensors are positioned so that they will not be tripped by small animals. Furthermore, since the first sensor to be tripped is upstairs, it suggests that it was being triggered by something that was still in the building at the time the alarms were armed and the building locked. Intriguingly, these events seem to suggest that someone or something begins their journey on the upper floor, now used for meeting rooms and office space, and which is not a point of exterior access for the building. The source of the movement then continues to tour down to the first floor before entering the kitchen, where it seems to vanish, but not before committing one last mysterious act. The alarm company reports that their phone calls are acknowledged. It seems the receiver on the kitchen phone is picked up to receive the call from the alarm company, but no one ever answers.

It should be noted that electromagnetic field (EMF) levels should be taken into account as one possible explanation for the personal experiences at

the site. There are EMF emissions produced in and around all wires and devices that use, carry or produce electricity. Often, paranormal activity is reported more frequently in rooms where the electricity enters the building. The combination of old and new wiring in the restaurant and the building's appliances and fixtures may produce EMFs that, in turn, could account for the apparitions and sounds, but not for all of the phenomena.

Garrett Husveth and I did one EVP session in the dining room and another session in one of the upstairs meeting rooms, but these sessions turned up no conclusive evidence or anomalous voices. For the moment, all that exists for evidence is a collection of personal experiences of some very levelheaded and respected people. What's more, similar phenomena have been reported by different people over a number of years. While this does help to bolster the validity of the accounts, it is the evidential, forensic results that still remain to be collected at this site at the time of this writing.

As Al, Garrett and I tell almost everyone we encounter, the phenomena and the causes for these phenomena are not going to harm anyone. There is no reason to fear the phenomena in this building; if anything, they should only serve to increase the charm of this historic building and enhance the fine dining experience guests will have at this superior restaurant and pub.

Chapter 5

THE GLADSTONE TAVERN

Whatsoever that be within us that feels, thinks, desires and animates is something celestial and divine and consequently imperishable.
– Aristotle

Gladstone, New Jersey, lies at the end of the railroad line. The hamlet still retains the small-town character that draws people to live among its pastures, ponds, storefronts, church steeples and clapboard and stone homes that line the town's roads. Surrounded by so much charm, it's hard to imagine that the town also contains a building that is reported to be one of the more haunted in northern Somerset County.

The Gladstone Tavern commands the northwest corner of Main Street and Pottersville Road, and it has a long and storied history that reaches back to the mid-nineteenth century. Originally built as a farmhouse in 1847, the building's first owners were Andrew and Sarah Rarick. They had one son of their own named Elias, but in 1867, Sarah's sister passed away due to a complication from childbirth. As a result, the Raricks decided to adopt one of Sarah's infant nephews named Edwin. Tragically, at the tender age of two, Edwin drowned in the Black River while visiting his aunt on the island just north of the Pottersville Bridge. In 1879, Andrew and Sarah bought the house on Pottersville Island, which looked out on the spot where their adopted son had died, leaving their farmhouse in Gladstone to become a stagecoach stop for a brief period of time.

Sometime about 1890, the structure was converted into the Gladstone Hotel. This establishment developed the reputation of drawing a rough crowd, and during Prohibition it is said to have operated as a speakeasy. Serving apple brandy, also known as "applejack" or "Jersey Lightning," it was supplied to the building by pipes that ran underground from the basement to a still that was hidden in the woods across the street. The hotel

Early view of the Gladstone Hotel. *Courtesy of the Gladstone Tavern.*

Vintage view of the Gladstone Hotel, at a time when the automobile replaced the horse and carriage. *Courtesy of the Gladstone Tavern.*

HOTEL GLADSTONE, GLADSTONE, N. J. H. S. VLIET, PROP. TEL. PEAPACK 12

View of the Gladstone Hotel with its upper porch, awnings and additions. *Courtesy of the Gladstone Tavern.*

may have also had a trapdoor that could be used to drop barrels of illegal alcohol into a secret room in the basement. In the early 1930s, the hotel was raided and the owner was arrested. Local tradition holds that the owner's son pled guilty so that his father would not have to go to jail. In the end, the son died behind bars while serving the sentence that should have been his father's. After Prohibition, a liquor license and a new owner named Harold Vliet softened the image of the Gladstone Hotel to the point where it was considered "comfortable and gracious."

World War II came and went, and so did the Gladstone Hotel, having been purchased by the Somerset Hills B.P.O. Elks Club and serving as the group's meeting hall until it was sold in 1971. The establishment reopened as the Willow Tree Tavern and kept this name for three years until it was purchased by the Karner family and renamed the Brass Penny. Nicknamed the "Penny" by locals, the restaurant became a very popular meeting place for drinks and dinner for eighteen years. In 1989, the restaurant was purchased by a group of local investors, renovated and reopened as Chatfield's. While still serving good food, Chatfield's developed more of a party atmosphere, with music filling the ears of its patrons.

However, the building was to undergo one more change and redefine itself in June of 2006 as the establishment we know (at the time of this writing) as the Gladstone Tavern. The current chef and owner, Tom Carlin,

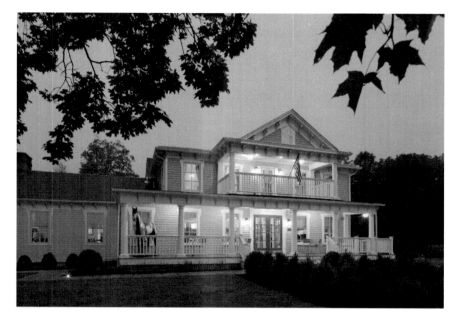

Current view of the Gladstone Tavern. *Courtesy of the Gladstone Tavern.*

redesigned the interior but kept much of the details that reflect the history of the building. In fact, Tom discovered a secret room in the basement of the tavern. Having no windows or doors, the small hole that was made through the mortar and stone walls reveals only empty space, a location that is thought to have concealed moonshine during Prohibition. Combining wonderful food and a reverence for history, the Gladstone Tavern is a delightful place to relax and enjoy good company, food and drink.

In the midst of such comfortable surroundings, it's hard to imagine that the building may be haunted, yet ghostly phenomena have been reported at the location for many years. The unexplained events connected with the site encompass all three categories of ghostly phenomena. Pinpointing the time when the phenomena began is difficult, and I would assume that people have had experiences in the building going back to the advent of the twentieth century.

However, there was a popular revelation of events that began to establish itself in the mid-1970s during the Brass Penny era. A ghostly image has been reported a number of times around the central staircase. The manager of the restaurant at that time even had an experience of his own. Near 12:30 a.m., the manager was about to close when he heard a sound near the stairway. Looking across the hall from his table in the dining room, he saw a "white kind of blur" move up the stairs. In addition to the sightings, doors

Stairway of the Gladstone Tavern where the ghostly figure of a woman was seen.

were often heard to slam in the early morning hours when the only person in the building was the manager or the owner; customers reported feeling a "presence" at their tables; and one diner in particular insists that he was poked on his back, yet when he turned around, nobody was there.

Second floor and stairway of the Gladstone Tavern where unexplained footsteps are heard.

The upstairs hallway and staircase seem to be the areas most associated with the sound of footsteps. In fact, the staff's sensing of a presence became so commonplace that they gave the perceived entity the name of Fred. A member of the owner's family distinctly heard someone walking in this upper hallway and just outside the office door while he was working in the second-floor office. Despite twice calling out "hello," he got up and looked to see who might be there. He found the hallway empty—the entire building was empty—but he reported that he could definitely feel something was there. Perhaps there was more than one soul there that night.

During the Chatfield years, the reports continued. Similar to what was experienced in the past, two staff members heard footsteps come out of the bathroom on the second floor and proceed toward the staircase. They waited to see if anyone would come down the stairs or go into the second-floor offices, a route that would have revealed the source of the footsteps. No one was seen, and a search of the second floor and the restrooms revealed no cause or explanation for the footsteps, although the realization that there were no other people on the floor was a bit frightening to the employees. Eventually, the given name of the ghost was changed from Fred to Freddy when a waitress saw the ghostly figure of a young boy in the stockroom and standing next to a door that led to the attic. The image of the boy

was detailed enough that he was described as wearing suspenders and blue pants. Some people suggest that the ghost of the boy is that of the son who took on his father's jail sentence when the Gladstone Hotel was a speakeasy during Prohibition. I personally don't think this is the case because a boy as young as that portrayed by the apparition would not have been old enough to have been incarcerated. Whoever the spirit is, the idea of a boy's ghost in the building became more and more accepted. As time went on, footsteps continued to be heard running around on the second floor in a manner that sounded like a child was playing. One of the waitresses even reported hearing Freddy call her name. With regular reports came the feeling of acceptance that the boy was a permanent part of the restaurant.

When the restaurant became the Gladstone Tavern, the ghostly phenomena continued to occur. While the owner, Tom Carlin, has not experienced anything himself, he has heard enough reports to keep an open mind on the subject. Unexplained noises continue to be heard, and a former manager regularly reported feeling an ominous presence in areas of the building that have been associated with the spectral sightings. Furthermore, one of this manager's last duties in the evening before closing was to arrange the napkins, cutlery and salt and pepper shakers in a particular fashion, so that they would be ready for the next day. Upon opening the restaurant the following morning, it was a fairly regular occurrence to find these items moved and completely rearranged from where she had left them.

Up to this point, there were no events to suggest that there was any intelligence associated with the perceived ghost. There had been no interaction between the ghost and the living witnesses and no change in the types of reported phenomena. The bulk of the experiences point toward a residual haunting; without further investigation, the movement of objects might even be classified as the generally short-lived poltergeist phenomena. The only event that suggests the possibility of an intelligent, apparitional situation is the report of the waitress hearing that someone called out to her, a possible example of direct voice. However, this was a personal experience, and, while it is an interesting report, there is no evidence to verify that her name wasn't spoken by another person inside or outside the building, or that imagination didn't have something to do with the perception.

It wasn't until Tom Carlin invited Haunted New Jersey in to gather forensic auditory evidence that this changed. As a result of the initial investigation, Garrett Husveth, who works as a professional computer forensic examiner, believes that his digital voice recordings point toward the presence of an adult male apparition in the building. Having voices that respond directly to questions helps to establish a sense of awareness that the entity has to the presence of the living, and this awareness places the phenomena squarely

in the apparitional category. Upon further investigation, we are hopeful to establish a larger body of evidence to support this theory.

Could there be more than one explanation for the phenomena at the Gladstone Tavern site? Absolutely! I feel that there is a mix of residual and apparitional phenomena occurring in the building at the same time. Place memories and an intelligent entity (or entities) are mingling in the same space, and future investigations and personal experiences will help to clarify just how many ghostly phenomena exist. For now, the staff and patrons of the Gladstone Tavern may rest comfortably in the warm, inviting atmosphere, knowing that they are immersed in history. It is very possible that whatever invisible energies haunt or linger within the walls of this wonderful establishment may feel just as connected as the living do to this historic site.

Chapter 6

PRALLSVILLE MILLS

It is possible that there exist emanations that are still unknown to us. Do you remember how electrical currents and unseen waves were laughed at? The knowledge about man is still in its infancy.
– Albert Einstein

Trying to determine the sources and causes of a haunting is somewhat akin to putting a jigsaw puzzle together when most of the pieces are missing. You can know the results and the experiences, much like the image on the puzzle box, but you don't know how the pieces all fit together. People often ask if someone died at a haunted site, but the answer to this might only offer up a small clue. Many paranormal researchers and parapsychologists theorize that intelligent, apparitional phenomena can be caused by the ghosts of people that lived or worked at a particular location. They can even be caused by the ghosts of people that enjoyed being at the site for one reason or another. I know that if I suddenly realized I had passed on and had the chance to choose where I would like to haunt, I certainly wouldn't choose to hang out in my condominium. I would go to other places I enjoyed in life.

There is another line of thinking that theorizes that ghosts visit or are grounded to particular locations because they have unfinished business or simply because they don't realize they've passed away, possibly due to a sudden death. Phenomena can also be caused by the living without them ever being aware of it. Taking all of this into account, one begins to see why detailing the history of a haunted location, including the people who currently inhabit the site, is an important step in learning about the possible sources of reported paranormal phenomena. Knowing the history of a location enables the investigator to broaden his or her questions for EVP, interpret results in a more informed manner and develop explanations for repeated experiences at the site.

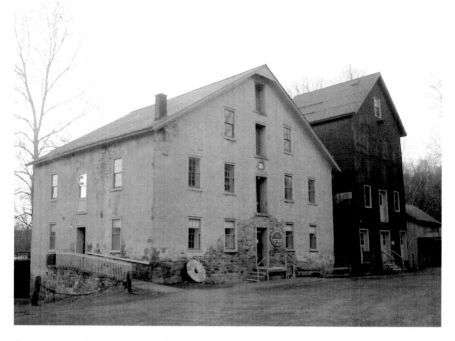

Current view of the gristmill and the granary at the Prallsville Mills in Stockton, New Jersey.

The Prallsville Mills in Stockton, New Jersey, is a location that offers itself up as a perfect example of a reportedly haunted spot that has hosted large numbers of people over an extended period of time going back to the early 1700s. After close to three hundred years of existence, it has seen its share of birth, life and death in the hamlet that surrounds it, and workers and patrons alike have crossed its thresholds since before the American Revolution. Today, it is a peaceful, picturesque row of historic buildings that grace the eastern shore of the Delaware River in Hunterdon County; this is a fairly recent incarnation, for it was, for the bulk of its existence, a bustling center of business and enterprise. The following history of the Prallsville Mills is quite extensive; much of it was taken from the Delaware River Mill Society, Inc.'s *The History of The Prallsville Mills 1717–1987.*

European settlement within the Delaware River Valley region of Hunterdon County began at the end of the seventeenth century with a period of considerable immigration that lasted until the middle of the eighteenth century. This immigration was originally dominated by a northerly movement of English settlers from the older West Jersey Quaker settlements that were located in the lower Delaware Valley. In the 1720s, this group was enhanced by a sizeable number of people of German

View of the Wickecheoke Creek from behind the gristmill, 2008. *Courtesy of Craig Schiavone.*

and Scotch-Irish descent who arrived from settled portions of eastern Pennsylvania. In addition, a smaller number of individuals came to the Delaware Valley from the older Dutch and English settlement areas of East Jersey and New York. Most of these early settlers were farmers who saw a great deal of potential in the fertile soils and excellent streams and rivers of the Delaware Valley region. Among the many tributaries of the Delaware

that drained the rich lands east of the river was the Wickecheoke Creek. The potential waterpower of the creek and the agricultural potential of the soils of the surrounding region contributed to the establishment of the first mill complex in the area that eventually developed into the settlement of Prallsville.

Among those participating in the early stages of the migration from the older settlements in the lower Delaware Valley was John Reading Sr., born in Staffordshire, England. In 1677, Reading purchased a proprietary share in the new colony of West Jersey, and by 1684, he had migrated to that colony, settling in Gloucester City on the Delaware River. In 1685, he was elected to the first of several terms in the West Jersey Assembly, and in 1686, he was noted as the owner of much of the land within the growing town of Gloucester City. Reading had arrived in West Jersey as a prominent and wealthy man who was immediately able to assume a position of both private and public influence.

Bear in mind that at the time Reading began making his land purchases, the region was a wilderness, and European settlements had not yet pushed into the area. Among the lands that were amassed by John Reading Sr. were considerable holdings in the section of northern Burlington County that in 1713–14 would be set off and established as Hunterdon County. Included therein was a large tract of land on the Delaware River to the north and south of Wickecheoke Creek in the present Prallsville-Stockton area. It was upon this tract that Reading established his Mount Amwell plantation during the first decade of the eighteenth century, making the final move northward when his home in Gloucester City burned down in 1711. John Reading Sr. is recognized as the first person of European descent to settle permanently within the bounds of Amwell Township. The center of the Mount Amwell plantation was located on the site of what later became the village of Stockton.

Reading died at Mount Amwell in 1717 and left a son, John Jr., and a daughter, Mary. When his father passed away, John Jr., as the elder child and only son, inherited the extensive landholdings and other property that his father had accumulated during his lifetime, an advantage that eventually allowed him to become the wealthiest man in Hunterdon County. John Jr. was extremely active and successful in public and governmental affairs, serving as a colonel in the county militia and as a county court judge. The majority of his public energies were spent as an official in the Colonial government, which included almost four decades of service as a member of the Governor's Council.

John Reading Sr.'s second child, Mary Reading, married Daniel Howell of Bucks County, Pennsylvania. Daniel Howell supposedly settled on land

given to him by his father-in-law shortly after his marriage. Howell, a farmer and miller who opened a copper mine, is also remembered as one of the first settlers in Amwell Township. In 1719, John Reading Jr. formally recognized the grant made by his father to Daniel Howell through the issuance of a deed transferring to Howell the ownership of a tract of land on the south side of the Wickecheoke Creek at its confluence with the Delaware River.

The first mill on the site was probably built by Daniel Howell during the second decade of the eighteenth century. It's felt that the mill was probably built using timber frame construction because it was the usual building method favored by those of Scotch-Irish descent in Colonial New Jersey.

The first primary source indication of the mill's existence is from a Hunterdon County document, recorded in 1729, pertaining to a proposed new road. This road was requested by several local residents, among them Daniel Howell, to run both north and south from "the said Daniel Howell's mill." The exact location of the original mill is unknown, but it is believed to have been close to the current mill's site.

Daniel Howell died on his Delaware River plantation in 1733. He had drawn up his last will and testament earlier in that same year, describing himself as a yeoman. The will noted and provided for his six children, all of whom were minors at the time of their father's death. Mary Reading Howell died before her husband, having passed away in 1732. The core of Howell's Delaware River plantation was to pass to his eldest sons, Daniel Jr. and John. They were to receive Howell's "Corn or Grist Mill" and the land, water rights and "Gears and utensils" associated with it.

Daniel and John Howell maintained their ownership of the mill property for only a few years. In 1750, they sold it to Charles Woolverton Jr. When he died in 1765, Woolverton Jr. left a will that ordered that his wife Margaret receive certain items of personal property and that she be provided for during her widowhood. His sons, Morris and John Woolverton, were given control of their father's real property holdings and were named as executors of his estate. Morris Woolverton was given the plantation, which included 268 acres in the Rosemont area that his father had acquired in 1731. Another piece of property, described as "the land on the South Side of the Wickecheoke that the gristmill stands on," totaling about 70 acres, was to pass to John Woolverton.

John Woolverton was born in Amwell Township, probably in the 1730s. In 1768, he married Elizabeth Wilson, also of Amwell. Together they had two sons, Charles and George. John, describing himself as a "miller," drew up his will shortly before his death in 1773. Several structures were mentioned, including a house, a barn and "the mill." The inventory of his personal property indicated the presence of a quantity of lumber, a crosscut

saw and "saw mill irons." This evidence, combined with the reference within the will of the "mills" of John Woolverton, suggest strongly that the latter had added a sawmilling operation during his eight year ownership of the mill, from 1765 to 1773.

In 1792, Charles and George Woolverton purchased the mill property from their father's executors for £1,500. The Woolverton brothers' interest in the property appears to have been limited solely to the profits its sale might provide because in 1794 they sold their recently acquired title to John Prall Jr. of Amwell Township, with the purchase price again being £1,500. Two years prior to this acquisition, Prall had purchased the former Reading/Howell farmstead to the south of the mill tract from the Ely family. This property, which the Ely family had acquired from Joseph Howell, totaled 280 acres; with the mill tract, this gave John Prall Jr. control of all the land on the Delaware River between the Wickecheoke Creek and present-day Ferry Street in Stockton. Prall's newly acquired property was described in the deed as including "a Corn or Grist Mill & Saw Mill with the Full custom Benefit in Grinding and Sawing."

John Prall Jr. was born in 1756, the fifth child and fourth son of Peter Prall III of Amwell Township. The first of this family to arrive in America was Arendt Jansen Prall, who was born in Holland but was of French heritage. The Prall family originally settled in the Hudson Valley at Kingston, New York, in 1660, but they soon moved southward and were among the earliest to settle on Staten Island. In about 1720, Peter Prall Jr., grandson of Arendt, moved to a farm on the present Back Brook Road just east of Larison's Corner in East Amwell Township. His grandson, John Prall Jr., spent much of his life on this farm before he made his purchases on the Delaware River in the 1790s.

John Prall Jr. participated in a number of military actions during the American Revolution, including the Battles of Monmouth and Germantown, and was wounded during the skirmish at Van Nest's Mill on January 20, 1777. After the war, Prall probably returned to his father's homestead on Back Brook. In 1795, he married Amelia, the daughter of John Coryell of Coryell's Ferry, and they went on to have three children, William L., Letitia and Sarah.

During the 1790s, the development efforts of John Prall Jr. enabled the small community of Prallsville to begin to take shape as a village, rather than just a milling complex of several related structures. Prall oversaw a construction program that resulted in the completion of a number of industrial, commercial and residential structures before the turn of the century. He is said to have built three industrial structures—a stone gristmill, erected on the site of the present gristmill and replacing the old Howell/

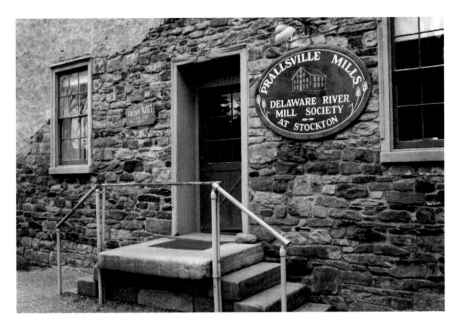

Entrance to the gristmill, 2008. *Courtesy of Craig Schiavone.*

Woolverton Mill; the present, stone-walled linseed oil mill; and a sawmill. Prall also built a stone store to serve as the focus of his commercial activities. The store was located on the northbound side of the present New Jersey Route 29 and just north of the John Prall Jr. House. Portions of it may survive within the stone dwelling that presently occupies this site. Prall also built two fine stone dwellings during the 1790s, the first of these being the aforementioned John Prall Jr. House now standing on the northbound side of Route 29 across from the mill complex. He also built the house that now serves as the Woolverton Inn on the hill to the east of the mill complex, and he apparently utilized this as his primary place of residence.

John Prall Jr. was most likely the sole proprietor and manager of the various industrial and commercial pursuits located on his property through the first decade of the nineteenth century. In addition to the mills and the general store, Prall also oversaw the agricultural activities on his 367-acre "plantation" and was the owner of two fisheries in the Delaware River. Prall further expanded his business pursuits by opening a sandstone quarry east of the mill complex early in the second decade of the nineteenth century. The continued development and expansion of the village at Prall's Mills eventually led to the establishment of a post office there (with the name "Prallsville" being officially adopted upon its arrival). At about the same time, the local name that had previously identified the area just south of the

Site of the Prall sandstone quarry, now filled with water.

mill complex, Howell's Ferry, was changed to Centre Bridge, reflecting the replacement of the former Reading/Howell Ferry by a new bridge across the Delaware. This was located on the site of the present bridge in Stockton and completed in 1814.

As previously stated, John Prall Jr. rebuilt the gristmill out of stone during the 1790s on the mill lot of the Wickecheoke Creek. It was said to have occupied the same general location as the present stone mill, but no one can be sure from the record that the 1790s mill stood on the site of the earlier frame or log mill of the eighteenth century. The substantial nature of the 1790s mill suggests that it contained a multi-run of stones, several additional mill machines and at least some of the labor-saving devices that moved grain, meal and flour from one processing point to another. This automation reduced the need for physical labor by the miller and his assistants and increased the mill's output at the same time.

During the second decade of the nineteenth century, John Prall Jr. was assisted in the management of his business affairs by his son, William L. Prall, and his son-in-law, Jacob Lambert. The younger Prall and Lambert, who were also partners in several other business ventures, took the operation of the store as their primary responsibility, while John Prall Jr. continued

to manage the milling interests and the quarrying activities. These were prosperous times at Prallsville. Mill products and other produce were shipped to markets such as Philadelphia and Trenton, both overland by wagon and in Durham Boats traveling down the river. Durham Boats were large, wooden, flat-bottomed boats made by the Durham Boat Company of Durham, Pennsylvania. Their use allowed them to be brought up the Wickecheoke and load cargo directly from the mill complex.

County road records from the early decades of the nineteenth century reflect the importance of the Prallsville industrial and commercial activities. In 1813, a new road was laid to connect Centre Bridge with the Prall-Lambert store. This road is now Route 29. In that same year, a portion of the road between the Prall's Mill and Baptistown, now County Route 519, was relaid north of its crossing of the Wickecheoke.

However, the spirit of expansion and prosperity that dominated the affairs at Prallsville during this period was short-lived. The failures of several business ventures placed young Prall and Lambert deeply in debt. Bankruptcy proceedings resulted, and in 1820 the partnership was dissolved, and all surviving assets were confiscated to meet the claims of their several creditors.

After the dissolution of the partnership between his son and son-in-law, John Prall Jr. offered a significant portion of his commercial and industrial properties for rent. An advertisement placed by Prall mentioned the availability of what essentially amounted to the entire "pleasant village of Prallsville, near Centre Bridge." Included were several of the properties formerly utilized by the Prall-Lambert partnership, notably the "Store-house," described as an "old established stand," and the "Pork-house." Also available, however, were two of the Prall mill properties, described in the advertisement as the "Saw, Plaister and Oil Mills." Prall had apparently concluded that the management of the gristmill and the quarry was as much as he could handle. Plus, at the time, whale oil was more economical to produce than linseed oil, which was pressed from flaxseed, so this helps to explain Prall's giving up this part of his operations. When all was said and done, he ended up offering his sawmill and oil mill for rent. The latter mill was also being used for the grinding of plaster during this period.

The mention of plaster milling reveals that the Pralls, not unlike other New Jersey millers of this era, continued to diversify their milling operations to include a new and hopefully profitable enterprise. Plaster for construction had obviously been made elsewhere in the community before this time. Even rooms in the log houses of the region's earliest settlements were often given plastered walls. Perhaps increased building in the area was the reason the Pralls were attempting this type of work. Just as likely, however, is the

possibility that the Pralls were grinding "land plaster," the earliest form of agricultural lime to prepare land for cultivation.

John Prall Jr. spent the end of his life in the farmhouse on the hill, now known as the Woolverton Inn, but he was moved down to what is known today as the John Prall Jr. House for his last days. He died in the back parlor on the first floor in 1831. The inventory compiled shortly after his death included specific references to some of the commercial/industrial aspects of his property. Prall's gristmill was mentioned, notably in a record that reported the presence of a stove in the "water house at the Mill," which was probably a reference to a wheelhouse constructed to protect the mill's waterwheel from the elements. The stove helped keep the wheel from freezing fast in winter when there was ample water to work. The sawmill was also noted, and the listing of two oil cisterns may be interpreted as a reflection of the inactive oil mill.

The Prallsville Mills property remained a part of the estate of John Prall Jr. for two years after his death. In 1831, the mill property was rented for a term of one year for $250. The widowed Amelia Prall maintained the farmhouse on the hill (the Woolverton Inn) as her residence until it, too, was sold off by her deceased husband's executors. The village of Prallsville continued to operate at a level of economic capacity that was much lower than the early period of the Prall ownership. In 1832, the present villages of Stockton and Prallsville were described as a single entity under the latter name and were noted as including a gristmill, a store, a tavern, six to eight dwellings and a fire bridge across the Delaware. No mention was made of the quarry or of any of the other mills.

The years 1831 and 1832, however, did witness the appearance of the first of several factors that would allow for the revival of the Prallsville Mills property. It was in these years that the feeder of the Delaware and the Raritan Canal was constructed within present-day Delaware Township. The Delaware and Raritan Canal's main route extended from Trenton to New Brunswick, which made it possible to travel by water from Philadelphia to New York without having to go around the southern tip of New Jersey. However, with so much water tied up in the operation of locks, the canal needed a reliable source of water to act as a feeder, and the feeder ended up drawing water from the Delaware just north of present-day Stockton. Originally intended as only a water supply, the feeder eventually allowed for grain and coal barges to move along its route. The construction and completion of the Delaware and Raritan Canal, which eventually carried more traffic than the famous Erie Canal in New York State, allowed for the recovery of the industrial and commercial complex at the mouth of the Wickecheoke. This revival began as early as the period of the canal's

construction, when the Prall quarry was worked by the canal company to provide the stone necessary for the assembly of locks, bridges, retaining walls and other canal-related structures.

In 1833, the executors of the Prall estate sold the mill property to William L. Hoppock of Solebury Township in Bucks County, Pennsylvania, and to John S. Wilson of Amwell Township. The land that was to come under the ownership of the partners was described as three adjoining tracts that included the village of Prallsville. Two of these tracts were the same parcels that had been acquired by John Prall Jr. from the Woolverton family in 1794, whereas the third was an 18.5-acre wooded lot that adjoined the other two to the north. The former Prall property was described as including "houses, store houses, gristmills, oil mills, saw mills, barns, stables, waters, water courses, ponds, pools, dams, races and sluices."

The most important action taken by Hoppock and Wilson in strengthening their control over the former Prall property was the formalization of the agreement John Prall Jr. had made with the Delaware and Raritan Canal Company. In return for Hoppock and Wilson's forfeiture of any water rights relative to the Delaware River, the canal company guaranteed that they would provide the water that was so vital to the operation of the mills from the feeder. This water, which would be "taken out of the dam to the mill across the Wickecheoke," would be sufficient to power three run of millstones. It was further stipulated that water for a fourth run of stones would be provided as long as the addition was not a detriment to the feeder canal.

The Hoppock/Wilson partnership was a brief one. Wilson sold his share in the former Prall property to Hoppock for $5,000 in 1834. In 1844, Prallsville, again including the Centre Bridge area, was described as including several dwellings, a store, tavern and mills that produced processed grain, plaster, oil and sawn lumber. The reference to the several milling functions was yet another indication of the return of expanded economic activities at the Prallsville Mills properties.

During the remainder of the first half of the nineteenth century, William L. Hoppock appears to have concentrated mainly on the revival of the several business pursuits that existed during the early years of the Prall ownership. Hoppock, who went on to become one of the largest landowners in Delaware Township, established the John Prall Jr. House as his residence. During his tenure, the mills, the store and the quarry were all reestablished as viable economic pursuits. The gristmill had probably remained active throughout the Prall period and may have required the least renovation. The oil mill/plaster mill was put back into operation during this period, possibly with both functions (oil and plaster production) existing interchangeably.

The former Prall store again became a prominent place of business under Hoppock's management, and he also renewed operations at what soon came to be known as Hoppock's Quarry.

In 1852, the transportation advantages enjoyed by the Prallsville Mills complex were further enhanced by the completion of the Belvidere Delaware Railroad through Delaware Township. This new rail line, known as the "Bel-Del," ran northward from the Trenton area along the feeder canal and provided important connections between the Hunterdon County section of the Delaware Valley and the southern markets such as Trenton and Philadelphia. The railroad company established a station in the Centre Bridge area, which had been renamed Stockton, with the opening of the post office that replaced the Prallsville Post Office in 1851. The presence of the station served as a catalyst for the early stages of development in the present area of Stockton. A similar expansion did not occur at Prallsville, and within two decades, Stockton had far surpassed the small village at the mouth of the Wickecheoke in both size and importance. However, Prallsville remained a viable business center, and the arrival of the railroad strengthened the industrial and commercial interests of William L. Hoppock.

The arrival of the railroad also appears to have sparked the return of sawmilling to the Prallsville Mills complex. The center section of the present sawmill structure was apparently built around the mid-nineteenth century, with the northern section added shortly thereafter. The railroad is said to have spurred this development both by providing useful transportation connections and by creating a demand for timber for its own wood-burning engines.

The village of Prallsville experienced a physical expansion during the 1860s. New dwellings were apparently constructed in the village during this period, several of which still stand at the time of this writing. It is said that eight dwellings existed in 1870, but several more may have stood at that time. It also seems likely that it was during the 1860s that William L. Hoppock converted the former Prall store to a dwelling and established the store in the former oil mill.

Among several possible reasons for the decline of the Hoppock business interests was the advancing age of William L. Hoppock. The elder Hoppock drew up his last will and testament in April of 1873, noting as his heirs among the seven children he would leave his three sons and business associates, John L., Samuel C. and William L. Jr. In the month preceding the date of his will, Hoppock had already sold much of his property holdings. One such sale was a tract of 120.87 acres that included his mills, store and quarry to Lemuel O. Kessler and William P. Corney, both residents of the city of Philadelphia. The purchase price for this valuable property was $40,000,

and the new owners reached a $30,000 mortgage agreement with Hoppock in order to finance it. In October of 1873, Lemuel O. Kessler became the sole owner of the Prallsville property when he purchased Corney's half-interest.

Lemuel O. Kessler's primary interest in his newly acquired property appears to have been the former Hoppock Quarry. The Prallsville quarries were apparently very active during the early 1870s, and Kessler's contacts in Philadelphia may have enabled him to acquire several valuable construction contracts in that city.

This second period of operation at the Prallsville Mills property came to an abrupt end with the destruction of the stone gristmill by fire on the afternoon of August 21, 1874. The fire was started by a spark from a passing freight locomotive that ignited the wooden railroad bridge at the mouth of the Wickecheoke. The entire bridge was consumed, and the fire eventually reached the nearby gristmill. The bridge was quickly rebuilt, and by the end of August 24, full rail service had been restored. However, the mill was reduced to a shell. Only its stone walls survived, and its restoration would require far more than a three-day effort.

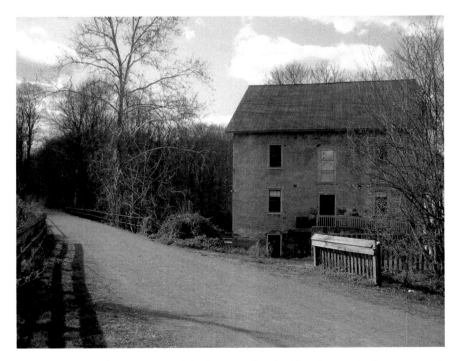

The Wickecheoke Creek and site of the former railroad bridge that caught fire and spread to the gristmill, destroying both on August 21, 1874.

In 1876, Lemuel O. Kessler, described as a former resident of the city of Philadelphia then living in the village of Prallsville, sold the stone shell that had been the gristmill, a shell that was described by John P. Prall in 1876 as being "almost a wreck." The stone remains of the gristmill and the 120.87-acre tract on which it was located was purchased by John Ramsey of Flemington, New Jersey. Ramsey was not, however, able to meet his financial responsibilities to the Hoppock estate, and in March of 1877, the executors of that estate brought a suit against Ramsey in the New Jersey Court of Chancery. In April, the court ruled in favor of the complainants and ordered that Ramsey's 120.87-acre property be sold to pay his debts.

On June 14, 1877, the sale of this very valuable real estate was advertised in the *Hunterdon Republican*. In August of 1877, the representative of the New Jersey Court of Chancery sold an 11.69-acre parcel from the former Hoppock property to Stout Stover of Allentown, Pennsylvania, for $8,100. This small tract included the gristmill site, the sawmill and the former oil/plaster mill. Immediately after Stout Stover acquired the former Hoppock property, he redeveloped the gristmill site. The new mill, which incorporated portions of the surviving stone walls of the former Prall/Hoppock mill, was completed in 1877.

The reconstruction of the gristmill during an era that was witnessing the abandonment of grain mills elsewhere in the region provided hard evidence of the site's continued advantages of accessible transportation and available raw materials. Furthermore, the continued high level of grain cultivation in Delaware Township, and in Hunterdon County in general, assured that the new gristmill would continue to have a necessary local function. Delaware Township lay within the county's most fertile region, and its agricultural lands were almost entirely devoted to grain cultivation. During the latter decades of the nineteenth century and into the twentieth century, Hunterdon continued to be one of New Jersey's leading grain-producing counties. Wheat, corn and oats—all major county products during the Hoppock tenure at the mill—remained prominent in the following decades and were joined by secondary grains such as buckwheat and barley. The region's high production levels could well support custom flour- and feed-milling activities, and the continued excellent transportation connections encouraged merchant milling as well.

In 1883, Stout Stover sold his mill property houses and lots of land situated at Prallsville to Joseph and John W. Smith of Lambertville for $19,000. The Smiths agreed to assume full responsibility for the $8,000 mortgage held by Samuel Stover. The family's newly acquired property was described as now including 12.44 acres with the addition of the dwelling on the opposite side of the present Route 29.

Joseph Smith, born in Pennsylvania in 1823, was a well-known and well-to-do businessman and industrialist in the city of Lambertville during the years following the Civil War. John W. Smith, Joseph's nephew, was also born in Pennsylvania, in 1848; by 1880, he too had relocated to Lambertville. A year before his death in 1888, the sixty-four-year-old Joseph Smith drew up his last will and testament. Smith noted his partnership in Joseph Smith & Company with his nephew John W. Smith and ordered that the business continue under the latter's management after his death. Furthermore, he ordered that his half-share in the firm pass to his wife, Susan B., and to his daughter, Mary I., his sole heirs.

After Joseph died in 1888, the firm continued to operate under the same name and under the management of John W. Smith up to the time of the First World War. The company's "flouring mill" was included in a statewide inventory of water-powered industry conducted by the Geological Survey of New Jersey in 1891 and 1892. It was additionally noted that the site's power source was the feeder, which provided eight and a half feet of fall and allowed for the generation of a net of forty horsepower. The decades before and after the turn of the twentieth century brought renewed expansion to the Prallsville Mills property, for the industrial and commercial pursuits of Joseph Smith & Company were both active and successful. The single most significant addition was the construction of the large, frame granary on the northwestern side of the gristmill. The sawmill was also increased in size through the construction of an addition during this period, and several structures were added to provide more storage space on the property.

In 1917, the family of John W. Smith gained full ownership of the Prallsville Mills property. In that year, the quartershares held by Susan B. Smith, who was an impressive ninety-two years old at the time, and by the executors of Mary I. Smith were purchased by the sons of John W. Smith. Two of John's sons, Charles A. and Joseph, were residents of Stockton and had probably been active in the family business for many years. With this transfer of ownership, the firm of Joseph Smith & Co. was dissolved in 1917 and replaced by John W. Smith & Sons. In 1921, the elder Smith conveyed his half-share to his sons, legally completing the control of the new generation. By the time of John W. Smith's death in 1923 at the age of seventy-five, the family business was operating under the name of J.W. Smith's Sons. At this time, the former Prall store was serving as the place of residence of either Charles A. or Joseph Smith.

The responsibility for the management of the family business appears to have descended to Edgar Smith, a son of one of the three Smiths, in the years following the passing of the three brothers. For approximately fifteen years, the mill and granary remained active in the milling and mixing of feed grains. The sale of lumber and fertilizer continued as well.

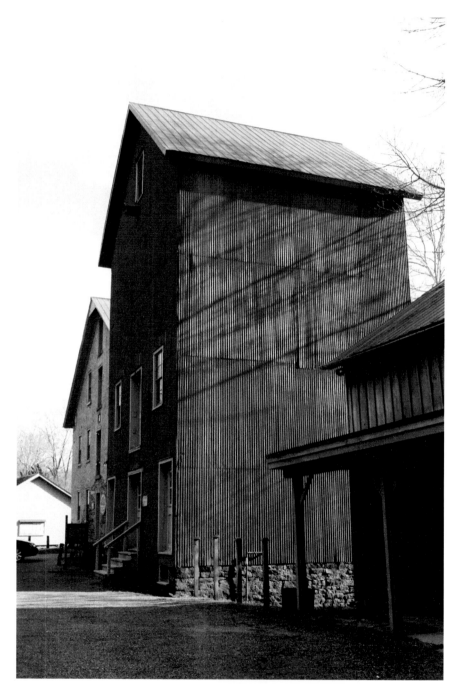

The granary at the Prallsville Mills historic area, 2008. *Courtesy of Craig Schiavone.*

Prallsville residents' headstones that rise above the rear cliff of the former Prall quarry.

In 1968, the mill finally shut down, and in 1969, the property was sold by the three grandchildren of John W. Smith to Donald B. Jones, who purchased the property for the purpose of transferring it to the State of New Jersey. In 1973, title to the property was transferred to the New Jersey Department of Environmental Protection (NJDEP) in the interest of its future preservation. In 1976, the State of New Jersey entered into the first of two lease agreements with the Delaware River Mill Society, an organization formed for the purpose of furthering the preservation of the mill complex. The second lease agreement was signed in 1982. In 1979, the Prallsville Industrial District, which includes the mill complex and much of the surrounding village of Prallsville, was placed on the National Register of Historic Places. In 2004, the Delaware River Mill Society and the NJDEP signed the third (and current) twenty-year lease of the Prallsville Mills.

If one walks the area today and wanders up to the top of the hill behind the old quarry, now filled up by ground water to make quite a sizeable pond, one will find a very old cemetery. This area holds the dead that used to live and work in Prallsville, and they command a superior view of the once-industrious village, their headstones looking down toward the rear of the John Prall Jr. House, the mill and the Delaware River. Standing witnesses to

Front façade of the John Prall Jr. House, 2008. *Courtesy of Craig Schiavone.*

the march of time, the names on these stones may well be the same as the entities that are said to haunt the area to this day. Reports of paranormal activity at the Prallsville Mills complex began shortly after opening to the public. With such an extensive history and succession of owners and workers, the list of potential spirits that may haunt these buildings is quite lengthy, and the reports of their presence involve three distinct structures.

The John Prall Jr. House is one of those places that looks as though it might be haunted. With its austere lines and dark stone walls, it's easy to imagine unseen eyes gazing out at you from behind the old window panes. With this type of impression, it makes it all the more important to approach an investigation of this house with caution. It's not because of the ghosts. Rather, it's due to the living. When gathering the reports of paranormal experiences, one has to be mindful of the fact that people's imaginations may be coaxed into working overtime in a location such as this. Every personal experience must first be examined for explanations other than the paranormal, and corroboration of the experiences would be good to have as well. After interviewing quite a number of people, there seem to be several experiences that warrant mentioning and are quite exciting.

The house has certainly been a silent witness to death over the years. John Prall's grandson wrote about how his sister had an accident in front of the large fireplace in the dining room. Her highchair fell over, and she hit her

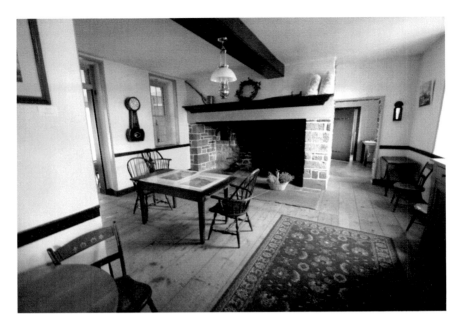

Beehive oven and hearth in the original kitchen of the John Prall Jr. House, 2008. *Courtesy of Craig Schiavone.*

head on the stone hearth. Within twenty-four hours, the child died from the concussive injury, most likely from a brain hemorrhage. It was mentioned earlier in the story about how John Prall passed away in the back parlor. To this day, staff members remark upon unexplained odors that manifest themselves in the house and particularly in this room. Ironically, Prall's sister died the very same day in the back bedroom on the second floor of the house, a mere eight feet from her brother's deathbed. This room is now an office, and the people who work in the house say that this room has a perpetual chill to it, and it is very difficult to keep warm, unlike the rest of the house.

The offices of the Delaware River Mill Society now occupy the second floor of the historic John Prall Jr. House, and the first floor remains much as it looked during the Prall era and contains exhibits of old photographs of the Stockton area. Suffice to say that when staff members are at work in the house, they are almost always working on the second floor. On one occasion, one of the interns was at the house; knowing she would be alone, she checked that all of the exterior doors on the first floor were locked before going upstairs to work in her office. She even closed all the interior doors behind her. While she was working, she heard a loud noise on the first floor. After shouting to see if anyone had come in, she went downstairs to

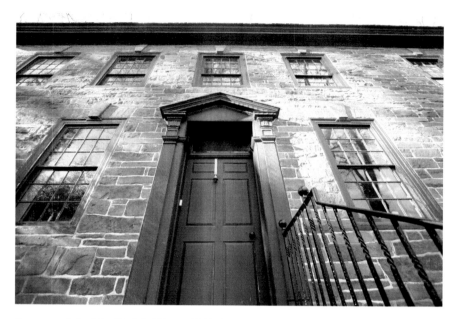

Entrance of the John Prall Jr. House, 2008. *Courtesy of Craig Schiavone.*

investigate the cause of the noise. During her tour of the first floor, she was quite unnerved to find that all of the interior doors that she had closed were now open, yet she was still alone in the house.

Many of the staff in the John Prall Jr. House have remarked that they don't like going into the attic because of a presence that watches them and makes them feel unwelcome. In addition, some of the workers have experienced unexplained auditory phenomena coming from the first floor. The front door has been heard to open, and footsteps have been heard coming in through the front door and walking across the central, formal parlor of the house. On other occasions, staff members on the second floor have heard a female voice calling "hello" on the first floor. Upon investigating the cause of these sounds, no satisfactory explanation has ever been found, and it needs to be noted that these events happened when the doors were locked—the front door locking only with a sliding deadbolt—and when the public had no access to the house. Indeed, in addition to Delaware River Mill Society staff members, the first floor of the John Prall Jr. House can be unsettling for outsiders as well. There is a report of a man from the New Jersey Water Authority that will not stay on the first floor of the house if he is alone because it makes him too uncomfortable.

During the investigation of the building, I recorded an EVP that captured an anomalous male voice in the back parlor of first floor. This is the room

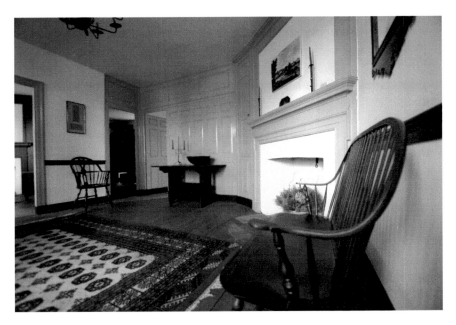

Formal parlor in the John Prall Jr. House, 2008. The second door from the left is the rear parlor where John Prall Jr. died. *Courtesy of Craig Schiavone.*

where John Prall died and now contains a photo exhibit. The DRMS director was leading me through the house and had just mentioned that she would be taking me upstairs to show me the layout of the second floor. In between two of her sentences, there is a Class A male voice that very clearly says "Up" (see no. 3 in Appendix), as if it were conscious of the fact that we should, or were about to, go upstairs. The identity of the male voice is up for conjecture. Could it be John Prall himself? Perhaps additional EVP work will record a name to shed more light on this question.

In the spring of 2008, photographer and videographer Craig Schiavone and I recorded two EVP sessions on the first floor of the John Prall Jr. House. Interestingly, we did our first session in the same back parlor where I got the "Up" EVP. It was after business hours, and the only other person in the house was the director of the Delaware River Mill Society, and she was upstairs in her office, which is located in what was originally the front-left bedroom. Several minutes after we began filming and recording, I asked if the entity could walk across the floor, knock, tap, move something in the room or do something else to let us know it was there. Almost immediately we heard walking upstairs, and it was loud. I noted on the recording that the background noises must be the director moving about on the second floor. We could distinctly hear heels and hard soles pacing across the floor directly

above our heads. Bangs were heard and then more walking. It went on for about five minutes while Craig and I were in the process of asking other questions (see nos. 4, 5 and 6 in the Appendix). Finally, growing tired of trying to record with the noises on the floor above us and the honking geese on the back lawn, we decided to move out of the back parlor and try our luck in the central, formal parlor, thinking it might be quieter. This second recording site was quieter, but we still had a couple instances in which we picked up what we assumed to be the director's pacing upstairs. Plus, we now had to contend with traffic noises from the street. After ten minutes, we thought it best to stop and wait for Garrett to join us.

As we were waiting, the director came downstairs to get something from her car, and she asked us how it was going. Craig and I explained how we were waiting for Garrett and had stopped recording due to the geese and her working and pacing upstairs. At this point, she gave us a very quizzical look, and said that she had not walked anywhere. Well, to be honest, we found it difficult to believe her at first. We suggested that maybe she had walked over to the file cabinet, used the bathroom or retrieved something from one of the offices above our heads. "No," she said very assuredly. "I was sitting at my desk and working on my computer since I left you in the parlor." She was absolutely positive that she had not moved, and, moreover, she hadn't even heard any noises on the second floor. All of the noises we

Staircase in the John Prall Jr. House, 2008. *Courtesy of Craig Schiavone.*

Second-floor hallway and offices where unexplained footsteps have been heard and recorded, 2008. *Courtesy of Craig Schiavone.*

recorded sounded like they were coming from just outside her office on the second floor, yet she heard nothing out of the ordinary.

At that point, Garrett arrived, and the three of us set out to recreate the walking sounds. One at a time, each of us went upstairs to walk the route of the unexplained footsteps, while the remaining two stayed below on the first floor to listen. We found rather quickly that we could not make the same sounds we had heard and recorded. First of all, we clearly heard the sound of heels and hard soles striking the floor. We had rubber-soled shoes that were much quieter. Secondly, there were only small sections of the floor where the floorboards were exposed. The bulk of the floor in the area that was above our heads during the EVP sessions was covered in rugs. Try as we might, no matter how hard we walked, the sounds of our footsteps were significantly softer and more muffled. To make matters even more puzzling, the director had very soft-soled shoes on her feet as well, and her pacing, during an attempt to recreate the recorded sounds, was softer and resulted in us hearing more of the creaking of the floorboards than the actual footsteps themselves.

Do I believe that the director wasn't walking around the second floor during our EVP sessions? Absolutely. Knowing what I do about her and our attempts to recreate the sounds, I believe the director was at her desk, just as she told us. However, the mere fact that someone was on the second floor

renders it impossible to label the footsteps as irrefutable paranormal evidence. The footsteps are certainly extremely interesting and intriguing, and they can be classified as unexplained phenomena; however, for the sake of the investigation's credibility, I don't feel they can be tagged as paranormal.

There are two other interesting recordings we got in the John Prall Jr. House. Our session in the central, formal parlor produced a clear, whispered male voice that said, "Seemed like he's a liar" (see no. 1 in the Appendix). Just who "he" is and what he might be lying about is unclear, but it appeared on our recording nonetheless. In addition, during the same EVP session in the back parlor in which we heard the footsteps, I asked if the entity could communicate to us through taps or knocks—once for yes, twice for no. At one point, I asked, "Is your last name Prall?" Immediately following this, we recorded a loud and distinct knock (see no. 2 in the Appendix) that came from the ceiling above Craig and me. Was it paranormal? I'm skeptical about random knocks, but it is interesting, considering the EVP and the extensive unexplained noises that we captured in this room.

There is a theory that proposes that people who die suddenly may not be aware that they are dead, and their spirits linger, trying to make sense of what has happened, especially if there is unfinished business or emotional ties holding them to a location. If this is true, then it's possible that the voice in the John Prall Jr. House may belong to a man by the name of James Water, for his situation satisfies the conditions of this theory to a T.

There is a 1938 newspaper reprint of an original article written on May 22, 1888. The subject of the article is an explosion that occurred that same year in the dynamite shack in the vicinity of the quarry. In fact, the dynamite shack was located behind the John Prall Jr. House, which was called the Quarry House at that point in time. It was reported that James Water, the foreman of the S.B. & E.W. Twinnings brownstone quarry, was killed instantly in the blast; after reviewing its effects, it's amazing that he was the only fatality. It is thought that Mr. Water accidentally spilled some gunpowder and ground it with the heel of his boot, causing it to ignite. The article states that his body was blown "to a thousand pieces," and his mustache and upper lip were found five hundred yards away in an apple orchard. In fact, the remains of his body were collected in a bucket! This event was made even more tragic by virtue of the fact that he was to be married several days later, and his hand was found with his fiancée's wedding ring on his finger. The blast itself was so powerful that it leveled a clapboard house down by the mill from which twelve Italian stonecutters managed to escape with their lives. Every window pane in Stockton was broken from the force of the explosion, and the blast was felt as far away as Newtown, Pennsylvania, some thirteen miles from the blast site.

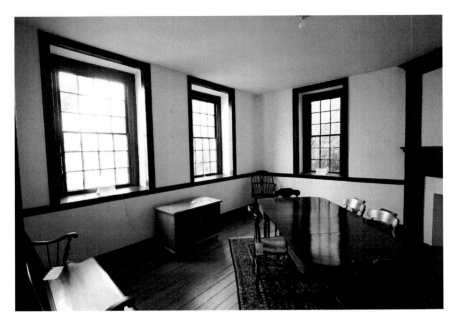

Dining room on the first floor of the John Prall Jr. House, 2008. *Courtesy of Craig Schiavone.*

In addition to feelings of being watched, disembodied voices and footsteps and doors that seem to unlock and open on their own, there are also occasions when objects will go missing, only to show up in very obvious locations. One instance involved a photograph of a woman who was named "volunteer of the year" at the Prallsville Mills. The director had promised to give the woman the photograph commemorating the distinction, yet when she went to retrieve the photo from the file, it was gone. The volunteer was disappointed at hearing the news, yet even she looked in the file to no avail. It was similar to one of those times that everyone has had when you look in places four or five times, hoping against hope that the object of your quest will materialize. Three staff members turned their offices upside-down looking for the photograph, but it seemed to have literally vanished. After some time, the search was ended. One year later, the director needed to look through the file for another reason, and to everyone's surprise, there laid the photograph of the volunteer, exactly where it was supposed to be. Where it was for the year's time it wasn't in the file is anyone's guess.

The granary/silo is the second structure that has established itself as an active location for paranormal phenomena. With its wood-frame construction and stairways, it is an area where one can easily imagine what the hustled activity of the workers must have been like as they moved from level to level in the course of their work. There is the feeling of being

watched by an unseen presence, most notably on the second floor and near the staircase. It's not a bad or threatening feeling, but staff members are constantly filled with the awareness that they are not alone in the silo. The most notable reported experience to come out of the granary centers around two employees who were cleaning up after a wedding party. This experience took place about 12:30–1:00 a.m., when it was very dark and still, and the two women were the only ones in the mill complex. Most of the time, these staff members are not bothered by the sounds of the mill, as they have become very familiar with its creaks and groans, the kind of sounds that one would expect old buildings to make. The noise that they heard in those early morning hours was, however, something completely different. The sound was loud, and it came from the upper reaches of the silo. The only way in which the two women could describe it was to compare it to the sound of working gears, as if the mill itself were in operation. Left with no way in which to explain what they were hearing, both staff members left, considering it just as easy to finish cleaning the following morning. If this noise was of a paranormal nature, it most certainly would be classified as a residual place memory, a sound from the building's past that was somehow being replayed. There is no reason to think that there was any intelligence linked to the sound, but this certainly doesn't make it any less unnerving when it's being experienced.

I recorded two EVPs on the second floor of the granary on two separate occasions, both of which may imply the presence of an intelligent entity and perhaps shed new and different light on the staff's experiences. The first recording was captured on the second floor of the silo near the center stairs. In fact, the digital voice recorder was set on the stairs while I spoke. In the recording, I can be heard saying the end of a sentence, "in the evening," and then I pause, thinking about what to say next. After the pause, I say, "and," and it's during this time when my voice is heard that one can also hear another clear male voice. The word that is heard over mine is a name, and it is a very interesting one because it corresponds with the history of the mill complex. The male voice says, "Woolverton" (see no. 7 in the Appendix), the name of the family that owned the mill from 1750 to 1794.

As I stated earlier in reference to the staff members' experience, buildings make noises that are completely natural and explainable. Older wooden buildings surely make more than their share of creaks and squeaks. Garrett and I were careful to make note of these over the course of our investigations at the mill. A certain amount of noise can be heard inside the structure from the limited traffic on Route 29, and the chill of winter air cooling down the building at night only adds to the sounds in the structure. I'm mentioning this because of the next EVP that I'm going to describe. My

Old machinery on the lower level of the gristmill.

son Cory and I were recording on the second floor of the silo along with Craig Schiavone, who joined us for the evening. I had asked if my questions could be answered with knocks—one for "no" and two for "yes." Now, let me be clear. I am very skeptical about knockings. Most times, they can be easily explained away, but when they continue to be heard, seemingly in

View of the gristmill's old timbers on the lower level and above the intake, water-power pit.

response to questions with a sound quality that is different from the others in the environment, I'm willing to look at them more closely and perhaps throw them in the hopper with the other evidence. Notice I used the term "evidence," not "proof." There were several questions asked in the silo that were followed by knocks that came from the floor around where we were

standing, yet none of us were moving, and we had already been stationary for several minutes. One of the questions I asked was, "Are you from the twentieth century?" The question was followed up with two sharp knocks, which could be interpreted as being a response meaning "yes." Other responses indicated that the source was male but did not work at the mill.

The mill building itself has four levels and has been renovated to allow for concerts, art shows and other special events, but some of the original machinery remains on display, which increases the interest and charm of this historic building. The lowest floor is open to the intake, water-power pit below it, so the sound of running water is always present. Added to this is a noisy, forced-air heating system, which is quite notable on the lower level. On the three upper floors, the only sound that one can hear is the rushing of air through the heat ducts. Traffic noise is all but eliminated by the thick stone walls, a major difference between the mill and the granary.

Several distinct experiences have been reported in the mill. As reported in the John Prall Jr. House and the granary, the mill also has a presence that can be sensed by both visitors and staff members alike. The employees of the Delaware River Mill Society report the presence to elicit a safe feeling, not malevolent at all, but it can be unsettling because one never feels completely alone in the building. Not everyone agrees with this evaluation. In fact, there is one deliveryman who refuses to set foot in the mill because it makes him feel too uneasy. The strongest sense of this other presence seems to be on the stairway leading to the second floor and on the second floor itself. I do not consider myself to be psychic, but I've been told that I am sensitive, and I do get the sense that I am not alone in these two areas, although I would say the same for the subterranean level, where a good deal of the old machinery is located. In addition, there are strange noises reported in the mill at night, sounds that don't fit the normal array for the mill.

The most unusual occurrence in the mill building itself had to do with an object that went missing for three months. In 2003, an employee of the mill had some trouble turning on the fans on the third floor. Deciding that a professional needed to be contacted, she walked over to the mill office to get the telephone number of the electrician, which was printed on a large yellow magnet, carried the magnet with her over to the mill and made the call. When she was leaving, she couldn't locate the magnet anywhere, and a search was mounted for this large yellow light bulb–shaped magnet, an item that would definitely stand out against the natural wood tones of the mill's uncluttered interior. Eventually the search was abandoned without luck. The next morning, the electricians arrived, only to find that the fans were working perfectly. Several months went by, and within that time, many events took place at the mill. After each event, the floors would be swept and mopped

Machinery on the first floor of the restored gristmill.

in addition to the regular cleaning and daily security procedures that took place within the mill. A full three months after the magnet disappeared, the same employee, accompanied by a volunteer, needed to show the mill to a group that was interested in using the space. The front door was unlocked, and the group followed the staff member and volunteer onto the ground level. After looking around for a bit, the group went up the stairs to the second floor. After locating the correct key to the second floor, the employee opened the door and stepped into the room. There at her feet lay the large yellow magnet, plain as day. There is no way that the magnet was there the night before this because this very same staff member herself had locked up. There are no nooks or crannies that could have hidden the magnet either. It apparently went missing very suddenly at the beginning of the summer, was not seen for three months and then reappeared at the top of the stairs and behind a locked door at the end of the summer. Since then, the mill's staff has become used to objects that change locations overnight or vanish, only to reappear a short time later. Some of them have even taken to blaming John Prall, often asking him to return the things that can not be found.

Several interesting EVPs were captured in the mill itself. During a recording session on the lowest level, I was asking if the presence in the

The author conducting an EVP session on the lower level of the gristmill, 2008. *Courtesy of Craig Schiavone.*

building had a family, and, if so, I mentioned how difficult it must be not to be able to see them. I then asked, "Are you with them now?" A response came in the form of what sounds like a boy's voice that said, "Yes." In addition to this, I recorded two voices on the second floor. One of them came in response to my asking if the presence knew the staff members, and I named them one at a time. When my question was finished, a deep male voice responded, "For one." Perhaps it meant that he knew one of the employees. Finally, I was explaining how EVP voices can not be heard with the human ear, but they are something we could hear later on a recording. Throughout our visit, I was continually asking for a name and explaining how that was the best information that could be given to us because it could be checked against the historical record. In the silence that followed, a gravelly male voice was recorded saying the name "Alex Dunning," a name that is not familiar to the staff members of the Delaware River Mill Society.

Just who this person Alex Dunning could be, or what significance the name has, still has to be determined, but the responses collected in the mill, granary and the John Prall Jr. House are encouraging. It's clear that people have had some very interesting experiences in these buildings, and the forensic evidence suggests that there is something here that warrants further investigation. Are the collected EVPs *proof* of ghosts haunting the Prallsville Mills? No, they are not proof, but they are evidence, and the evidence indicates that there are anomalous voices that seemed to respond to our presence and our questions. Often, EVP responses increase in regularity as the research continues. If this pattern holds true for the Prallsville Mills, then the unseen spirits who share the shadowed spaces of the mill complex with us may one day be accepted as being as much a part of this historic area as the stone and wood buildings that surround them. For now, the histories of locations similar to the Prallsville Mills and the ghosts that haunt them find new life in the stories. The stories are sustained in personal experiences, the experiences can be supported by forensic evidence and the evidence points to the very real possibility that we share this world with those who have gone before us. If there is an energy within us that survives our physical death, then the environments in which we live may be far more haunted and alive than we realize.

Chapter 7

THE GREAT SWAMP

It is the secret of the world that all things subsist and do not die, but retire a little from sight and afterwards return again. Nothing is dead. People feign themselves dead, and endure mock funerals and mournful obituaries, and there they stand, looking out the window, sound and well in some new disguise.
– Ralph Waldo Emerson, Essays: Second Series *(1844)*

At first glance, this vast, sprawling area that lies just east of Basking Ridge and straddles the Passaic River may seem to be rather unimpressive to many people, but don't be fooled by first impressions. Look closer and you will find a land rich in environmental purpose, history and reports of paranormal occurrences.

Comprising more than five thousand acres, the Great Swamp is now managed by both the Somerset County Park System and the U.S. Fish and Wildlife Service, and includes marshy pools, swamp woodlands, upland woods and dense thickets. It is hard to imagine the changes this land has seen through time, and even harder to imagine what this land almost became.

In prehistoric times, this land was at the bottom of Glacial Lake Passaic, formed when the Wisconsin Glacier (which stopped just to the north of this area) receded about ten thousand years ago. The resulting meltwaters formed the lake that lasted approximately four thousand years. After the lake drained, woolly mammoths roamed the land. The skeleton of one of these immense creatures was reported in a 1908 newspaper article to have been found in the area, and its exact location was mentioned as being a mile from the intersection of White Bridge and Carlton Roads. In 1990, there was even a small reward offered to anyone who could find the exact location of the skeleton. To this day, the location of the skeleton remains one of the secrets that the swamp has not revealed.

View into the Great Swamp in Basking Ridge, New Jersey.

Thousands of years before Europeans arrived in the area, Paleo-Indian groups inhabited the area. Several hundred years ago, the last and most recent in the area was the Lenape tribe, as discussed in chapter three. Numerous artifacts from one of their settlements have been found in archaeological digs within the Great Swamp, shedding quite a bit of light on their culture and day-to-day activities.

In more recent times, the area we know as the Great Swamp was logged, burned, drained, farmed and then abandoned. Between the years 1765 and 1771, William Alexander, better known as Lord Stirling, built his country estate on a portion of this land. This manorial estate, built in the English pattern, was lavishly appointed and extravagantly decorated with only the finest materials and furnishings. Alexander was born in New York City in 1725, but he actually went to Great Britain to recover a lapsed Scottish title that his family once held. William Alexander proved his claim to the title according to a Scotch law, and, since the claim was for a Scotch peerage, this seemed to have settled the matter. However, he was persuaded by friends to go a step further and present his case to the House of Lords in London as a matter of courtesy. The decision by the House of Lords was not reached until after Alexander's return to America, when they decided the claim

Remains of a former outbuilding from Lord Stirling's estate.

could not be allowed because Alexander had failed to show that heirs in a direct line were extinct. Deciding that the ruling of the Scotch court was enough, William Alexander assumed the title of Earl of Stirling upon his return to America and continued to be known as such in both his public and private life to the day of his death.

When the war began, Stirling was the first to volunteer in the Somerset County militia, becoming a brigadier general and then a major general in the Revolutionary War. He went on to become a personal friend of George Washington and serve heroically at the Battles of Brandywine and Monmouth. It also appears that Lord Stirling was a rather arrogant and pompous fellow, one who took his assumed title a bit too seriously. In fact, his fondness for his title was sometimes the subject of jokes made at his expense, even among his friends. On one occasion, when a deserter was about to be hanged, the soldier who was acting as the executioner gave the condemned man a few moments to commune with his maker. The soldier fell down on his knees and called out in terror, "Lord, Lord, have mercy on me!" Lord Stirling was standing near the gallows, and, assuming the plea was addressed to him, turned to the condemned man and said in a loud voice, "None, you rascal, none! I won't have mercy on you!"

In 1779, Stirling hosted General Greene, who established his headquarters at Stirling Manor. There is even information that describes a 250-foot-long tunnel, long since collapsed and filled in by farmers, that Stirling planned to use as an escape route into the Great Swamp if it were needed during the war. Eventually, ownership of the estate passed into other hands immediately after the close of the war and Lord Stirling's death in 1783.

Farming continued to take place in the drier portions of the swamp throughout the following century. By 1898, Colonel John Jacob Astor IV owned a good deal of the property on the western side of the Great Swamp. As fate would have it, Colonel Astor became one of the many people who perished in the sinking of the *Titanic* in April, 1912. By the early 1900s, a cattle farm was established on the property. This farm was eventually sold to John Jacob Astor VI. It was he who built the dairy barn that became part of the Lord Stirling Stable and part of the Somerset County Park Commission on December 21, 1967.

In the 1960s, there was an incredible and successful effort on the part of local citizens to prevent the Great Swamp area from becoming the fourth New York–area jetport. With plans to put two runways in the swamp, the whole of Somerset and Morris Counties would have been dramatically affected. Today, as one looks around the picturesque hills, towns, farms and open spaces that surround the Great Swamp, it is hard to imagine that this area was once very close to resembling the congestion and noise that one finds in and around Newark, JFK and LaGuardia Airports.

Today, the Great Swamp area is home to many species of animals, including thousands of waterfowl and songbirds. Hikers and naturalists can take advantage of trails and wildlife observation blinds, and families can take advantage of a plethora of environmental programs for children and adults.

Moving through the area, one is surrounded by a vast mixture of textures, sounds and sights. Open meadows give way to stands of trees, and these stands of trees quickly become dense, wooded regions punctuated with rivulets and standing pools of water. Dividing the swamp, and acting as the border between Somerset and Morris Counties, is the steadily flowing Passaic River, moving with a strength and sense of destiny that almost gives it a life force of its own. The river was given its name by the Lenape people, for whom the word "Passaic" was a place-name meaning "valley."

In the winter, fantastic patterns can be seen in the ice that forms over the surface of the river. Delicate geometric latticework graces the glittering river and reveals fallen leaves from the previous autumn that lie trapped underneath the frozen shell. The stubs of cattails jut up from the river's edge, thirsting for the thaw of spring, and hoarfrost crunches in the flash-

frozen soil when crushed under the weight of a hiker's boot. Spring brings the waterfowl, and birds of every type seem to appear out of nowhere, filling the region with trills, whistles and song. Summer is filled with many kinds of insects, and the vegetation appears to be almost impenetrable in many spots. Even on the hottest days, the swamp remains much cooler. The sheer magnitude and diversity of life within the swamp seems to have no end; eventually, autumn eases in, and the days shorten. The woods go yellow and red. Milkweed pods split and fill the air with downy white wisps, each one carrying a seed on the breeze. The crickets of late summer and early autumn cry in the early evening, and the area quickly slips out of its foliaged skin, leaving the trees to stand like bones in the shorter, darkened days of early winter.

The cycle of life within the Great Swamp carries on from year to year, and throughout the time in which the area has hosted human occupation, several reports of paranormal events have found themselves to be cemented within the mystique of the swamp.

It's been said that if you go to the swamp at night and stand on the bridge that crosses the Passaic River, you can hear the cries of the Lenape people echoing down from the Lenape Meadow within the Somerset County Park section of the swamp, where these people once camped so many years ago. Another explanation for this mournful sound is more disturbing. Reports tell of Lord Stirling keeping slaves, a practice that was not unusual in the time of our country's forefathers. The empty shells of these slave houses once stood on the grounds of the old estate. However, the story of slavery takes a brutal turn with the report that any slave children who were not physically perfect were taken to the Passaic River and drowned. Some residents have come to think that the cries they hear are actually the voices of these slave children calling out for help.

In the 1960s, a creature similar to Bigfoot was seen crossing White Bridge Road and quickly making its way into the brush on the opposite side. Walking upright, covered with hair and standing well over six feet tall, it surprised, and was spotted by, a passing motorist who stopped to get a better view of the creature. However, the creature, camouflaged by the color of its fur, blended into the environment and disappeared into the woods.

Have you heard of the Jersey Devil? Well, the Great Swamp boasts of being the home of a similar creature that has become known as the Swamp Devil. Spotted by people as recently as the 1990s and described by at least one source as a "sharp-faced witch," it was first reported by a Presbyterian minister in 1740 while he was riding his horse to Elizabethtown. According to the minister, he was surprised by the creature, which he described as having short arms, legs similar to a human's and a large head with eyes of

an emerald-green color. It climbed up a tree but then descended toward the minister while making a horrifying, shrieking sound of someone being plunged straight into hell.

In the late 1970s, there were two Somerset County Park naturalists who surprised a mysterious, unknown creature one evening in an empty building that was boarded up on the property of Lord Stirling Park. Having just stepped into the house, the men were struck by a rank odor of decay that permeated the building. Following their noses toward the source of the stench, they finally descended the stairs to the cellar, where the smell was the strongest. Without warning, a screeching, fur-covered animal ran past the two naturalists, bounded up the stairs and dashed out of the building. The two astounded men were left in the foul-smelling room surrounded by an assortment of animal skeletons. Well, as you might imagine, the sudden, unexpected encounter frightened the employees, but it also unnerved them because they could not identify the creature either by sight or by the piercing, shrill cry that it made during its hasty exit. Every known large mammal was ruled out, leaving the naturalists to ponder just what it was that they saw. Plus, this creature ran swiftly on two legs, not four. Could they have seen the Swamp Devil? Was this an animal species that has yet to be discovered and named? Perhaps we'll never know for sure, but, to this day, there are individuals that prefer not to walk alone in the woods toward the back of the park property because they feel as if they are being watched and shadowed, some even say stalked, by something unexplained and hidden in the dense trees.

People in the area have also reported seeing the ghost of a little girl. Given the name of Amy by the local police, she is said to have died before the American Revolution by drowning in a well. Since then, her apparition has been seen from Basking Ridge to New Vernon and Meyersville. Said to be between the ages of four and nine, her ghost is seen by motorists as floating several inches off the ground, especially on Cross Road in Basking Ridge and the New Vernon Road that runs north out of Meyersville. Legend has it that her apparition was once even seen by George Washington, who stopped his carriage to pick up a little girl in a white nightdress walking in the snow. When his footman approached the girl, she simply vanished, leaving no trace of footprints in the snow.

Other reports have circulated regarding modern-day Basking Ridge residents seeing ghosts of Revolutionary War soldiers walking out and along the edges of the swamp. People have speculated that these spirits are those of men that died at a hospital building of experimental design that General Washington had built in the area to care for the sick soldiers during the 1779–80 Morristown encampment. The location is thought to have been to the

east of town and on rising ground in a meadow near the edge of the swamp. Dr. James Tilton, a physician and surgeon in the Hospital Department, is the man traditionally credited with having designed the hospital building. Using the plan of an Indian hut, Tilton's one-story log structure provided a three-ward hospital with a large central section and two smaller wings built at right angles to the central room. All three of these wards were separate units, with no windows or doors in the walls between them. The hospital, equipped with bunks, accommodated twelve patients in the central section and eight in each wing. In cold weather, a fire was built in the middle of each ward, yet there were no chimneys. Instead, the smoke circulated and escaped through an opening that was about four inches wide in the ridge of the roof. The patients were placed with their heads to the nearest wall and their feet turned to the fire. The smoke, Tilton wrote, combated "infection, without giving the least offense to the patient, for it always rose above their heads, before it spread abroad in the ward." Thus, he maintained, he had provided a small, uncrowded and completely ventilated hospital in which patients suffering from fevers could be separated from the wounded (for more information, see James Tilton's *Economical Observations on Military Hospitals and the Prevention and Care of Diseases Incident to an Army*).

An area on the edge of the Great Swamp in Basking Ridge where a Revolutionary War hospital was located.

Out of the roughly four hundred men who required hospital care during that winter, at least 21 percent of them did not survive. Military hospitals, as noted by several sources from the time, were not places one went to get well—they were places one went to die. In a letter written to the Pennsylvania Committee of Safety on December 4, 1776, Anthony Wayne called the hospital at Ticonderoga a "house of carnage" in which the dead and dying lay mingled together. Even Dr. James Tilton was appalled by the loss of life in military hospitals. He was convinced that more men were "lost by death and otherwise wasted, at general hospitals, than by all other contingencies that have hitherto affected the army, not excepting the weapons of the enemy" (again, see Tilton's *Economical Observations*). Dr. Benjamin Rush, a prominent physician of Philadelphia who served in the Hospital Department, was equally condemnatory. "Hospitals," he wrote, were "the sinks of human life in an army" (Rush, *Medical Inquiries and Observations*). In a pamphlet published by order of the U.S. Board of War in 1777 and addressed to the officers of the Continental army, he observed that a "greater proportion of men have perished with sickness in our armies than have fallen by the sword" (Rush, *Directions for Preserving the Health of Soldiers*). It's no wonder, given these horrific conditions, that some of these tortured souls may linger, having suffered for an extended time waiting for death and never returning to the homes and loved ones with whom they yearned to be reunited.

One of the most famous stories of the area—a tale about the Headless Hessian—has been told since the time of the Revolutionary War, and it may actually be the inspiration for one of the most famous ghost stories ever told. In the late 1770s, three Hessian soldiers were riding through Basking Ridge. Hessians were German mercenaries hired to fight on the side of the British. As these three unfortunate soldiers made their way through the village, townspeople attacked them. One of the soldiers suffered a stab wound through his chest, and the second lost his arm. The third soldier got the worst of it, and had his head all but severed from his body. His head remained attached by only a few strands of flesh. Tangled in the reins, the Hessian's lifeless body was carried off into the swamp, still mounted in the saddle on his white horse. The bloodied horse was later found, but its rider was never located. Since that day, and right up into present times, people have reported seeing the specter of a horse and its mount, a headless rider, in and along the edges of the swamp—most often in an area known as Devil's Den just west of the Environmental Education Center on Lord Stirling Road.

As I mentioned, the ghost of the Headless Hessian has been well known for quite some time, and there is reason to believe that the story may have

Devil's Den, the section of the Great Swamp said to be haunted by the ghost of the Headless Hessian.

influenced American writer Washington Irving (1783–1859). While there is a German folktale that may have helped stir Irving's creativity, it's very plausible that the source of Washington Irving's inspiration was more heterogeneous, including this local tale as well. Irving spent a good deal of his time living and working in and around New York City, and it's thought that Irving came across the tale of the Headless Hessian while he was in New Jersey doing research for his biography of George Washington. Having become so enamored with the story of this unfortunate German mercenary, Irving then took it back with him, reset it to take place in 1790 and within the Sleepy Hollow glen of Tarrytown, New York, created the character Ichabod Crane and published the story of "The Legend of Sleepy Hollow" in 1820. Since then, this short story has grown to become an American favorite, but it started right here in the Great Swamp.

Several years ago, I had the pleasure of befriending a gentleman named James who had a personal encounter with the Headless Hessian, and his story is quite interesting. Believe me when I tell you that the terror in his eyes was still plainly noticeable when he retold his experience to me, and I will recount it here exactly as it was told to me.

John Quidor, *The Headless Horseman Pursuing Ichabod Crane*, 1858, oil on canvas, $26^{7}/_{8}$ x $33^{7}/_{8}$ in. *Courtesy of the Smithsonian American Art Museum.*

On a cold, late-February night, in the mid-1980s, James and three of his friends had planned to attend an owl walk that was being offered in the Great Swamp. These guided walks are done in the evening and usually coordinated to take place during a full moon so that it is easier to see the trail. Well, it turned out that there was a conflict with one of his friends' schedule, and neither James nor his friends made it to the walk. Not to be deterred, they decided to do their own owl walk the following night. It is of extreme importance to note that, at the time of this walk, nobody in the group had ever heard of the Headless Hessian or any other story of this sort associated with the swamp. The night was clear and the moon was still very bright. Driving to a trailhead, they parked their car, and made their way into the trail with flashlights and maps in hand. They only walked a hundred yards or so before stopping to check the map and listen for owls. They did hear something, but it was not an owl. From over his shoulder and further up the trail, James heard the snorting of a large animal. Turning around, they were stunned to see a dark figure of a horse with a headless rider. The figure was only fifteen yards or so up the path from them, and it stretched across the width of the trail. While they watched, the specter turned to face them. Fearing that they would be approached, all four men raced out of the trail, jumped into the car and wasted no time driving away from the site of their stunning encounter. While in the car, they swore to each other not to mention this to anyone, lest anyone think they were crazy. James remembers that it was the most frightened he has ever been.

Several years passed, and, having never found a suitable explanation for what he had seen, James found himself sitting in a friend's house. It was early autumn, and he happened to be reading through a local magazine that was on the coffee table. Suddenly, there it was. There in front of him was the story about the Headless Hessian of the Great Swamp. It was explanation enough for him, and he felt validated, for now he knew that his experience and those of his friends were not isolated, and they were similar to the ones shared by others for over two hundred years.

As far as documentation and forensic evidence of the Headless Hessian is concerned, there is not much that can be presented except for the personal experiences of witnesses. There are no photographs or EVPs, but this lack of physical evidence also doesn't *disprove* the existence of this haunting or entity. Studying the reports, there is nothing to indicate that this ghost is anything but residual energy. It has never interacted with anyone. It's seen in roughly the same area each time it is sighted, all within the boundaries of the swamp and mostly in the Devil's Den area. As residual energy, it would be a replay of past events. While our visions of Irving's Headless Horseman paints the mental picture of an entity with an intelligence, the

One of the sites in the Great Swamp where the ghost of the Headless Hessian has been seen.

Headless Hessian, while frightening for witnesses to behold, may have no more capability of doing you harm than an image on a DVD.

This swamp and any of the other locations in this book may hold residual energy and hauntings from people that have lived before us. Indeed, they may even be visited by the spirits of men and women who have passed on to another plane of existence but still interact with us for various reasons. Whatever the explanations may be for the phenomena that have been experienced in these historic locations, I prefer to think of them all as opportunities, portals that enable us to make contact with people from the past who may have walked the same ground as us yet still exist in the present. At the same time, whether the phenomena are residual or intelligent, the experiences and the collected evidence offer us a chance to touch history in a very unique and personal manner. We may call these places haunted, and we may refer to the phenomena as ghosts, spirits, entities, residual energy or place memories, but they are also historic, and there is a very real chance that they may just provide us with glimpses into our own future.

APPENDIX

The following list of EVPs, mentioned in this book, can be heard on the Haunted New Jersey website.

Simply log on to http://www.hauntednewjersey.com/historichaunts/index.htm, and follow the directions from that point.

These brief EVP descriptions will let the reader know what he/she can expect to hear.

PRALLSVILLE MILLS—STOCKTON, NEW JERSEY

1. "Seemed like he's a liar." (Male voice recorded in the central, formal parlor of the John Prall Jr. House.)
2. One knock. (Recorded in the back parlor of the John Prall Jr. House.)
3. "Up!" (Male voice recorded in the back parlor of the John Prall Jr. House.)
4. Walking: Part 1. (Recorded with the other two parts in the same five-minute session in the back parlor of the John Prall Jr. House.)
5. Walking: Part 2. (Recorded with the other two parts in the same five-minute session in the back parlor of the John Prall Jr. House.)
6. Walking: Part 3. (Recorded with the other two parts in the same five-minute session in the back parlor of the John Prall Jr. House.)
7. "Woolverton." (Male voice recorded on the central stairway on the second floor of the granary.)

Former Vealtown Tavern and Bernardsville Library—Bernardsville, New Jersey

8. "No." (Male voice recorded in the balconied, upper room.)
9. "Just Stuck." (Male voice recorded in the bedroom with the closet.)
10. "Say it!" and "Sick with woe!" (Two male voices communicating with each other and recorded in what used to be the Children's Reading Room of the former Bernardsville Library.)
11. "Go, listen…Uh!" (Female voice recorded in what used to be the taproom, but the voice was coming from the front room, directly across the hall from the taproom.)
12. "I'm down…in the wall." (Female voice recorded in what used to be the taproom, but the voice was coming from the front room, directly across the hall from the taproom.)
13. "Tap it out." (Female voice recorded in what used to be the taproom.)

New Jersey Brigade Area—Bernardsville, New Jersey

14. Anomalous footsteps. (Recorded at the hearth site.)

BIBLIOGRAPHY

Barber, John Warner, and Henry Howe. *Historical Collections of the State of New Jersey/Somerset County History.* Cooperstown, NY: H. & E. Phinney, 1847.

Basking Ridge Historical Society. *Van Dorn Mill.* Basking Ridge, NJ: Basking Ridge Historical Society, 1972.

Bataille, Larry. "The Phantom Carriage & Other Ghost Stories." *New Jersey Country Roads Magazine* (Autumn 1993): 55–57.

Bernardsville History Book Committee. *Among the Blue Hills: Bernardsville, A History.* Bernardsville, NJ: Bernardsville History Book Committee, 1973.

Bill, Alfred Hoyt. *The Campaign of Princeton 1776–1777.* Princeton, NJ: Princeton University Press, 1948.

Billias, George Athan. *George Washington's Generals.* New York: William Morrow & Sons, 1964.

Butler, Tom, and Lisa Butler. *There is No Death and There Are No Dead.* 1st ed. Reno, NV: AA-EVP Publishing, 2004.

Delaware River Mill Society, Inc. *The History of The Prallsville Mills 1717–1987.* Stockton, NJ: Delaware River Mill Society, Inc., 2004.

Force, Peter. *American Archives.* 5th set. 3:1359. "Wayne to PA. Committee of Safety. 4 Dec, '76."

Gillett, Mary C. "From Defeat to Victory, June 1778 to 1783" from "The Army Medical Department: 1775–1818." http://history.amedd.army.mil/booksdocs/rev/gillett1/ch5.htm.

Historical Booklet Committee. *Historical Booklet of Bernards Township, NJ.* Basking Ridge, NJ: Historical Booklet Committee, 1960.

Johnston, Eileen Luz, comp. *Phyllis—The Library Ghost?.* Newark, NJ: Johnston Letter Co., Inc., 1991.

Lawrence, Susannah, and Barbara Gross. *The Audubon Society Field Guide to the Natural Places of the Mid-Atlantic States: Inland.* New York: Pantheon Books, a division of Random House, Inc., 1984.

McNealy, Terry A. "Historic Stockton." *Hunterdon County Town & County Living* (Summer 2006): 63–71.

Mundy, Marian H. "Folklorist Recounts Tales of Spooks and Devils in the Great Swamp." *Bernardsville News*, October 29, 1992, Second Section, 8.

New Jersey Historical Society. *N.J. Brigade Encampment in the Winter of 1779–1780.* Newark, NJ: New Jersey Historical Society, 1968.

The Olde Mill Inn at Basking Ridge. "Grain House Restaurant." The Olde Mill Inn at Basking Ridge. http://www.oldemillinn.com/grain_house_basking_ridge_nj.html.

Parker, Cortlandt, Jr. "Group Invites Public to Join Great Swamp Mastodon Hunt." *Bernardsville News*, July 19, 1990.

Risch, Erna. "The Hospital Department" from "Supplying Washington's Army." http://www.history.army.mil/books/RevWar/risch/chpt-13.htm.

Rush, Benjamin. *Directions for Preserving the Health of Soldiers, Addressed to Officers of the Army.* Philadelphia, PA: published by order of the Board of War, 1777.

———. *Medical Inquiries and Observations.* 2nd ed, 5 vols. Philadelphia, PA: published by order of the Board of War, 1784.

Schumacher, Ludwig. *The Somerset Hills: Being a Brief Record of Significant Facts in the Early History of the Hill Country of Somerset County, New Jersey.* New York: New Amsterdam Book Company, 1900.

Sharp, Edie (director of the Delaware River Mill Society, Stockton, New Jersey), in an interview with the author, January 23, 2008.

Tilton, James. *Economical Observations on Military Hospitals and the Prevention of Disease Incident to an Army.* Wilmington, DE: Wilson, 1813.

Wolfe, C.G. "Indelible Memories: The Ghosts of the Gladstone Tavern." *The Black River Journal* (Fall 2006): 30–35.

ABOUT THE AUTHOR

Gordon Thomas Ward is a writer, presenter and educator. Born in Tacoma, Washington, his family moved to New Jersey when he was eleven months old. Both of his parents were talented artists and enjoyed the outdoors. Ward's family divided their time between the family's home in Bernardsville, New Jersey, and a summer cottage in Maine. After high school, Mr. Ward went on to major in fine arts and psychology at Fairleigh Dickinson University in Madison, New Jersey, where his father was a botany professor.

Gordon currently divides his professional time between writing, lecturing and being the Director of Youth and Family Activities at a Presbyterian church. He has worked as a history teacher in the classroom and as a group-transformation facilitator in the experiential education field where he designed and facilitated teambuilding programs for twenty-two years. Clients have ranged from education groups in international, conference settings to major corporations, government groups, athletic teams, community groups and individuals. Mr. Ward is currently a member of Haunted New Jersey, a premier group of paranormal investigators who have accrued over seventy-five combined years of investigation experience, including the collection of forensic evidence to both dismiss and support claims of hauntings, especially in historic locations.

A lifelong writer, Mr. Ward's works have included books, speeches, newspaper and magazine articles and poetry. Gordon is the author of *Life on the Shoulder: Rediscovery and Inspiration along the Lewis and Clark Trail* (Lucky Press, 2005) and a self-published book of original poetry entitled *Windows* (1994). *A Bit of Earth in the Somerset Hills: Growing Up in a Small New Jersey Town* (The History Press, 2007) brings the author back to the land where he spent his childhood. With echoes of Wordsworth and Thoreau, *A Bit of Earth* is a timeless meditation on the meaning of childhood. Mr. Ward's newest book, *Ghosts of Central Jersey: Historic Haunts of the Somerset Hills* (The History Press, 2008), explores paranormal events and hauntings at historic locations in Hunterdon and Somerset Counties in New Jersey.

The author currently resides in Bedminster, New Jersey, where he continually pursues his other passions for songwriting and running.